Shino

Shino

Ryōji Kuroda

KODANSHA INTERNATIONAL LTD.
Tokyo, New York, San Francisco

Translated by Robert N. Huey

Distributed in the United States by Kodansha International/USA Ltd., through Harper & Row, Publishers, 10 East 53rd Street, New York, New York 10022

Published by Kodansha International Ltd., 12-21 Otowa 2-chome, Bunkyo-ku, Tokyo 112 and Kodansha International/USA Ltd., with offices at 10 East 53rd Street, New York, New York 10022 and at The Hearst Building, 5 Third Street, Suite 430, San Francisco, California 94103.

LCC 83-48287
ISBN 0-87011-631-2
ISBN 4-7700-1131-8 (in Japan)

Library of Congress Cataloging in Publication Data

Kuroda, Ryōji, 1905–
Shino

(Famous ceramics of Japan; 12)
Translation of: Shino
1. Shino pottery. 2. Pottery, Japanese—Edo period,
1600–1868. I. Title. II. Series.
NK4340.S5K8713 1984 738.3'7 83-48287
ISBN 0-87011-631-2 (U.S.)

Shino Ware

The Origin of Shino

Until the advent of Shino ware, no white-glazed pottery was made in Japan. The Momoyama period (1573–1615) was an age dominated by the tea ceremony, an age in which great tea masters—Takeno Jōō, Sen no Rikyū, Furuta Oribe—appeared on the scene, setting standards of taste and demanding a steady supply of tea ceramics. They were enthusiastic about Shino ware, with its soft, white glaze.

These tea masters are indeed praiseworthy as arbiters of the tea ceremony aesthetic, but one cannot help admiring as well the artistic sensitivity of the artisans who actually created the pottery. The kilns where they worked were founded at Ōgaya by Katō Genjūrō Kagenari, and at the village of Kujiri by Katō Kagenobu. This mountainous region is not particularly isolated, yet something of the past lingers there today. These places still retain their heritage as pottery villages.

It is impossible to draw a clear line between Shino ware and Oribe ware, though one may say that the primary Shino glaze is feldspathic, while Oribe ware is known for its use of copper green and iron brown. Yet it is fashionable these days to distinguish the two wares, so that practice will be followed here.

The effect of the flames of the kiln on pottery is sometimes different from the one intended. In the semiunderground kiln—the type of kiln in which Shino was traditionally fired—much heat is lost. If the fire is not kept burning for a long time, the kiln will not reach the 1200° C. necessary. For many reasons, red pine is the best fuel for firing such kilns. The struggle to reach the high temperature necessary may last for several days, and it is no wonder that potters offer prayers to the gods of the kiln.

Each time I visit the old kiln sites at Mino I am deeply moved. I envision the potters going back and forth bearing loads of firewood. I can imagine their joy when the kiln is ready to be unloaded, and even more their despair if the firing proved a failure.

Deep in the mountains of Mino things are as they have always been. In the spring the plum trees blossom, and violets bloom along the paths. In summer, the irises and water lilies are out. In autumn, pampas grass plumes appear just about the time the bush clover is putting out its graceful flowers, and the wild grapes are turning color. Persimmons have been strung to dry from the eaves of a mountain house; their shadows are silhouetted on the translucent shoji screens. In winter, if a wood thrush comes to pay a call, it is caught in a fine mesh bird net. All of these subjects were given lively expression at the hands of the potters who decorated Shino and Oribe ware.

The Origin of Shino

Under the Ashikaga shoguns, Muromachi period culture was given direction by three great masters—Zeami, Nōami, and Geiami. Following them came Shino Sōshin (1444–1523), revered as a pioneer in the art of incense and reputed to be a discerning tea master as well. In his time, aristocrats and those surrounding the imperial family amused themselves with such elegant contests as trying to guess the type of incense by its smell or the origin of a tea by its taste.

There is a theory that Shino ware was inspired by a white Chinese teabowl in Sōshin's possession. Another theory has it that the name came from a tea caddy called "Bamboo Grass" (also pronounced *shino* in Japanese) owned by Sōshin. There are a number of other explanations as well.

The following entries appear in a tea ceremony chronicle covering the year 1716: "white Shino ware," "a water container of Shino ware," "a Shino ware tea caddy," and "a tea caddy of Shino Oribe." It would seem then that the term "Shino" came into use around the first decade of the eighteenth century. It is easy to understand the excitement felt by Momoyama period tea ceremony connoisseurs

when they first laid eyes on Shino's white glaze.

Leaving aside the traditional theory that Shino ware came about when potters in the Seto region were commissioned by Shino Sōshin to make pieces to his taste, we turn to the *Honchō tōki kōshō* ("An Examination of the Pottery of Our Land"), written by Kanamori Tokusui in 1857, for a more complete examination. Kanamori consulted a variety of sources in compiling this work. Part of the section on Shino ware reads as follows:

"Shino Sōshin had a favorite white-glazed, 'shoe-shaped' bowl, imported from South Asia, which he used as a teabowl. This bowl is said to have been owned later by Imai Sōkyū (1520–93)." The *Meibutsuki* ("Record of Famous Products"—1660) states that Shino teabowls originated in Owari Province (present-day Aichi Prefecture) as imitations of this bowl. In fact, Shino teabowls closely resemble pottery from southern China and South Asia, and can usually be distinguished from the latter only by close examination of the clay. Shino ware, Oribe ware, and "Picture" (*e*) Karatsu ware are difficult to tell apart. Indeed, they are often simply called "Shino Oribe."

Shino ware is made in various styles, sizes, and qualities. Among the many kinds of Shino teabowls, good and bad, ones with a reddish tinge are highly prized. There is also a kind of Shino called "Plain Shino" (*muji Shino*), which is unpatterned but often has a reddish tinge. Even among pieces of this type, there is a great deal of variety. Some of these pieces have been fired very hard, and their glaze is a pure white with no hint of red. All Shino ware appears rather soft, but it is actually quite hard. There are a few examples of Shino teabowls with pictures on them.

Ken'ichirō Ono's 1932 history and lineage of the kilns at Mino, called *Owari no hana* ("Owari Flowers") has this to say about Shino: "In the first month of 1574, Kagemitsu, third son of Kageharu of the thirteenth generation after the first Seto potter Katō Kagemasa, moved to Akatsu. By virtue of a tea jar that he presented to the lord Oda Nobunaga, the latter formally recognized him as a retainer. Kagemitsu subsequently left Seto and moved to Kujiri, in Mino, in 1583. There he changed his name to Yōsanbei and continued working as a potter. He died in the eighth month of 1583 and was buried at Seian-ji temple."

About Kagemitsu's son Kagenobu, Ono says: "During the Tenshō era (1573–92) he moved to Kujiri to be with his father, and practiced pottery there."

"Under the tutelage of Mori Yoshiemon of Karatsu, in Hizen Province (Karatsu is in present-day Nagasaki Prefecture), he studied Karatsu kilns and later built a Karatsu style kiln himself in Mino. The quality of his work progressed rapidly, and he discovered a white glaze. He presented a teabowl he had made to Retired Emperor Ōgimachi. On the seventh day of the seventh month (late August) of 1597 he was given the title Chikugo no Kami, and he worked for Tsumaki Genban no Kami. He died in the second month (late March) of 1604."

These accounts would seem to give the most accurate descriptions of the origins of Shino ware.

Early Influences—Momoyama Period
The Momoyama period marks the division between Japan's medieval and late feudal ages. It was a time of vigorous artistic activity and an era when the fields of politics, Buddhism, painting, technology,

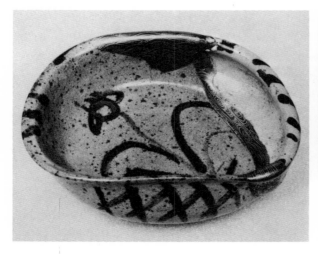
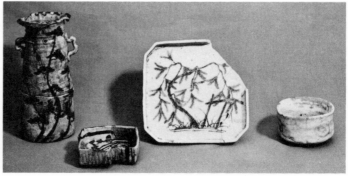

From right to left: Shino teabowl; Shino Oribe dish; Oribe small serving dish; Mino-Karatsu ware flower vase. Left photo: Picture Karatsu small serving dish. The pots pictured show the close affinity of Karatsu, Shino, and Oribe wares.

building, landscape gardening, and so on, produced people of extraordinary talent.

The dominant imperial figure during this period was Ōgimachi, who reigned first as emperor then later as retired emperor. The Takeda and Uesugi families were battling for control of the eastern provinces. Oda Nobunaga and Toyotomi Hideyoshi each had their days of rule. The prominent local military lords were Katagiri Katsumoto, Mōri Motonari, Tōdō Takatora, Gamō Ujisato, Tokugawa Ieyasu, and Date Masamune. Among the aristocrats at court, Ichijō Kanetaka and Konoe Sakihisa were in favor. Warlords such as Maeda Toshiie, Ukita Hideie, and Kobayakawa Takakage had their moments on the stage of history. It was an age when people were frantically taking what they could get at the expense of the nation.

This was also an age of superior men in other fields. At Daitoku-ji temple there was the priest Kokei Sōchin, to whom Hideyoshi and Sen no Rikyū turned for instruction, and the priest Shun'oku Sōen, said to have converted Nobunaga to Buddhism. Other outstanding figures included the famous master swordsmen Miyamoto Niten (also known as Miyamoto Musashi) and Tsukahara Bokuden, Hon'ami Kōetsu (the calligrapher, potter, tea master, and evaluator of swords), and the poet of Chinese verse Ishikawa Jōzan.

In the fields of calligraphy, Japanese poetry, and painting, there were such artists as Kaihō Yūshō, Kanō Eitoku, Hasegawa Tōhaku, Tawaraya Sōtatsu, Kusumi Morikage, Karasumaru Mitsuhiro, and Shōkadō Shōjō. The number of great figures in this age is truly astonishing.

It was also in the Momoyama period that Japanese pottery reached its peak. To be sure, this pottery did not just suddenly burst forth from nowhere. It had its roots in the Kamakura and Muromachi periods. But unquestionably, it was the commitment to culture of such powerful men as Nobunaga and Hideyoshi that nurtured this pottery and helped bring it into its own.

According to old pottery records, in 1563, during the rule of the shogun Ashikaga Yoshiteru, Oda Nobunaga made an inspection tour of his fiefs. At the time, he designated six potters from the Seto region of Owari as "the Six Artisans." They were Moemon, Chōjū, Shimbei, Shunhaku, Sōemon, and Ichizaemon. In fact, these six were not just potters.

They seem also to have been aesthetes who traveled to and from the kilns at Seto and the cities of Kyoto and Osaka. Their identities are not absolutely clear. It has been established that there was a Shimbei who came from a merchant house in Kyoto at Yanagi no Bamba, who marked his work with a kiln mark in the shape of a capital letter "T" and who also made pottery at the Bizen and Shigaraki. Pots bearing the "T" kiln mark are, without exception, skillfully made works. A green Oribe "shoe-shaped" teabowl in the author's possession has the "T" mark, and is indeed a fine piece, though one cannot say for sure whether the Shimbei who made it was the same Shimbei whom Nobunaga designated as one of the "Six Artisans" of Seto, since the name Shimbei was quite common.

Tōkurō Katō believes that the Shimbei who used the "T" kiln mark is probably the same person as the Shimbei honored by Nobunaga. But the possibility is also strong that the Shimbei who used the "T" kiln mark came from a family who ran an antique shop on Kyoto's Sanjō, for an old book says of this Shimbei that "he made excellent tea caddies."

Kanamori Tokusui, compiler of the above-menioned *Honchō tōki kōshō*, and chief retainer of the Tamaru fief in Ise Province (in present-day Mie Prefecture), had a profound knowledge of tea ceremony as well as of antiques. The name Shimbei and the "T" kiln mark are mentioned in his book.

An earlier record of Seto's ten best potters was compiled by Furuta Oribe in 1585. This lists the following potters along with their kiln marks: Hanshichi, Rokubei, Kichiemon, Hachirōji, Sasuke, Motozō, Tomojū, Kinkurō, Jōhachi, Jihei.

From the Momoyama period through the Edo period, Shino ware was without exception dominated by the Oribe taste. In fact, the entire range of Japanese pottery was influenced by each of the great tea masters in succession. Sen no Rikyū's preferred style held sway in the Tenchō, Bunroku, and Keichō eras (1573-1615). Furuta Oribe's was preeminent in the Keichō and Genna eras (1596-1624). And Kobori Enshū's tastes prevailed from the Genna through the Kanbun eras (1615-73). After these three followed Katagiri Sekishū.

Of course, Shino and Oribe ware reflected the interests of Furuta Oribe. But Enshū after him favored works ordered from Korean kilns, and these im-

ported pieces, in turn, had a strong impact on Japanese ceramics, as even a cursory look at such pottery will reveal.

Rikyū favored Setoguro and the Raku ware teabowls of Chōjirō. In addition, there was Rikyū Seto and Rikyū Shigaraki, which reflected that master's taste. Besides Seto and Mino, Oribe's influence was also strong at the kilns that made Karatsu ware. Indeed, one cannot help but admire the breadth of taste and influence seen in these great tea masters.

The Beauty of Shino

The Azuchi-Momoyama period, dominated by the three statesmen, Nobunaga, Hideyoshi, and Ieyasu, was a transitional age between the tumultuous Muromachi period and the Edo period. Against the backdrop of various local lords continually going to war for their own gain, the Momoyama period nonetheless represented a new age for Japanese pottery.

There are thirty-some kilns scattered through the two counties of Kani and Toki in Mino. It is here that the purely Japanese wares of Setoguro (also called Tenshōguro or Hikidashiguro), Kiseto, Shino, Oribe, Mino-Iga, and so on, were first made.

To be sure, in the distant past there were kilns here as in every province, firing unglazed or ash-glazed folk pottery to meet the demand for everyday ware. Yet it is noteworthy that in this area the potters broke free from tradition and began to experiment with new decorative techniques to suit the requirements of the tea ceremony. This was an important step.

The main reason behind this burst of creativity was the increasing demand for tea ceremony pottery. The development of ceramics at these kilns paralleled the growing popularity of the tea ceremony that revolved around Sen no Rikyū and Furuta Oribe.

In the past, merchants of the region were always going back and forth between Mino and the big cities of Kyoto, Osaka, and even Edo. Probably because of this, Kuguri, Ōhira, and Kujiri, being on the Kiso River and thus on the river trade route, prospered.

The founder of the Ōgaya kiln in Kuguri was Katō Genjūrō Kagenari. It is not certain exactly when he moved from Owari to Ōgaya, but it must have been sometime in the Tenshō era (1573–91)—about four hundred years ago.

Meanwhile, in Kyoto, the tea master Sen no Rikyū was commissioning works to his specifications from the first of the Raku potters, Chōjirō. Though the exact connection, if any, has been lost to history, Genjūrō Kagenari began firing black Setoguro teabowls similar to those produced by Chōjirō. The difference was that as a rule Chōjirō's teabowls tended to be small, while the Setoguro teabowls made in Mino were larger.

Kiseto and Shino ware, which were younger cousins of Setoguro, deviated from the standards set by Rikyū. They were more decorated, more consciously artistic. Rikyū dismissed them as ''peculiar,''

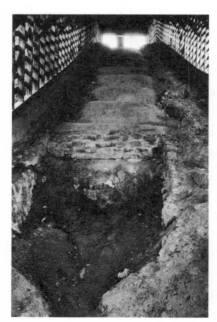
The old Motoyashiki kiln site at Kujiri.

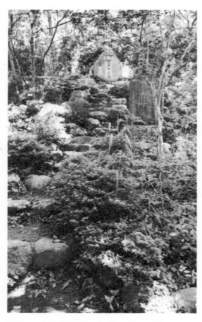
Memorial for Katō Genjūrō Kagenari.

The old Kamashita kiln site at Ōgaya.

but they unmistakably reflected the taste of Furuta Oribe.

Tōkurō Katō and the late Hajime Katō believe that it is wrong to make a distinction between Shino and Oribe ware. They maintain that Shino ware covered with a white feldspathic glaze should be called "White Oribe," while the ware decorated with copper green glaze should be called "Green Oribe." I agree.

Shino ware was so highly prized by tea masters and connoisseurs of old pottery because of the purity of its white surface, and its warm, quiet charm. The late Yasunari Kawabata, winner of the Nobel Prize for literature, was one who apparently felt drawn to Shino. He owned several famous Shino pieces himself, and a Shino teabowl figures prominently in his novel *The Thousand Cranes*.

I, too, must confess an abiding love for Shino ware. More than once my meager resources have gone into the purchase of a Shino piece. To me its charm lies in the feel of its surface and the mellow luster that accords so well with that surface. And there is the straightforward beauty of the pictures decorating Shino ware. The overall effect is intoxicating.

Shino pictures are drawn with lively lines depicting the everyday scenery surrounding the potters— the bridges over the streams at Kuguri, a cypress fence and dew-covered path leading to its brushwood gate, a grove of trees in flower, the trees and grasses just outside the window, even the mountain road they traveled day after day.

Such was the aesthetic of the Momoyama period in general. But the single tree, the few blades of grass these artists sketched are somehow pleasing because the designs pulse with life, the brushwork is clean and bold.

The white of Shino ware can be compared to that of the first snow of the season, or to the last traces of the winter snow, which the warm spring winds are erasing as the bush warbler's first song rings out. Shino's white surface is soft like a mother's breast; it brings back memories of childhood.

Shino white is tidiness itself. And on that white the potters painted designs with an iron glaze made of *oni-ita*, a red clay rich in iron and manganese and abundant in the Seto region. The effect of flame in the kiln added distinctive fire marks. Shino is an elusive ware, capable of infinite transformations.

The Shino potters thickly applied their glaze, which they made by carefully grinding feldspar and refining it in water. To this they added their own secret proportion of ash. Then, after offering saké and prayers to the gods of the kiln, and ritually scattering salt to purify the area, they entrusted their pieces to the fire.

Shino ware is the spirit of tea, the essence of pottery. It is the result of the flames of the kiln.

> In the depths of the heart
> From which pottery springs
> Flows a crystal clear stream
> Reflecting nearby mountains.
> —*Rosanjin Kitaōji*

Rosanjin wrote of Shino: "Among glazed Japanese pottery of the medieval period, the white of Shino ware is most unusual.... In the finest of Shino pieces, the design on the white glaze, or the brownish tinge that appears around the parts of the piece that have turned a pleasing red, are a delight to the eye."

Nowadays it is the ceremonial teabowls that are the most prized Shino ware, along with serving dishes, incense boxes, and *hi-ire* (ceramic cups used to hold glowing embers for lighting pipes). But these were not the only things made by the Shino potters.

Shino Kilns

The major Shino kilns and their locations are as follows: the Kamashita, Mutabora, and Naka kilns of Ōgaya in present-day Kuguri-Ōgaya, Kani District, Kani County; the Yuemon and Inkyo kilns of Ōhira in present-day Ōhira, Kani District, Kani County; the Motoyashiki, Takane, and Shōbu kilns of Kujiri in present-day Kujiri, Izumi District, Toki City; the Ōtomi kiln in present-day Ōtomi, Izumi District, Toki City; the Jōrinji and Entogawa kilns of Jōrinji in present-day Jōrinji, Izumi District, Toki City; and the Kamashita kiln of Tsumaki in present-day Kamigō, Tsumaki District, Toki City. According to Tōkurō Katō, the kilns at Ōgaya were the earliest, followed by those at Kujiri, which were in full production from around the first quarter of the seventeenth century.

The Mutabora, Kamashita, and Naka kilns of Ōgaya were all in production at about the same time and were responsible for the best Shino pieces. The teabowl *U no Hanagaki* ("Fence of Deutzia Flowers"—Plates 2, 3) is an example of the work

from these kilns. Their pieces were usually bold in execution, like the powerful water container named *Kogan* ("Weathered Shore"—Plate 1), now in the Hatakeyama Collection. Other striking examples from the Ōgaya Kamashita kiln include the teabowl *Mine no Momiji* ("Summit Maples"—Plates 14, 15), owned by the Gotō Art Museum, and the teabowl *Yama no Ha* ("Mountain Ridge"—Plate 10), owned by the Nezu Art Museum.

The Mutabora kiln of Ōgaya was known for its rectangular dishes with "picture frame" (*gakubuchi*) rims. To be sure, such pieces were also made at Ōhira and Kujiri kilns, but the bowls thought to come from Ōgaya are superior.

A close examination of the feet on the set of five undecorated saké cups shown in Plate 50 gives the strong impression that they were made by the same potters at the Ōgaya Kamashita kiln who made Kiseto ware. One is fascinated by the straightforward yet unexaggerated statement of the potter's wheel found in these cups.

Both the plain Shino saké bottle, unearthed at the Takane kiln site, and the saké bottle with design of willow branch (the two pieces are seen in Plate 9) are thick-walled and obviously made to be used. They appear to have been made sometime in the first quarter of the seventeenth century, when Oribe taste was dominant.

It appears that from the Genna era (1615–24) onward, articles for daily use were fired alongside tea utensils at the linked-chamber climbing kiln at Motoyashiki. In addition to tea ware, lamp accessories, smoking utensils, a rare seal stamp, high-quality ceramic rests for ink sticks, many water droppers for measuring water onto the inkstone, and innumerable similar small items were fired there, but very few of them have the Shino glaze.

To be sure, not every Momoyama potter was a master. Yet the Gray (*nezumi*) Shino produced at Kujiri and Ōhira (particularly at the latter's Inkyo kiln) was of uniformly high quality. And pieces from the Takane kiln, like the incense box in Plate 41, show a bold, sturdy character somewhat different from the thin-walled pieces fired at Ōgaya.

The Motoyashiki kiln also produced many small saké cups with squared rims and squeezed-in sides. These cups are thick-walled and decorated with pictures of violets, pampas grass, cypress fence, water lilies, and so on. Beautiful color changes occurred inside them during the firing.

Hardly any writing accessories produced at the Shino kilns have been handed down—extant pieces are excavated objects. The monkey-shaped water dropper unearthed at Ōgaya shows beautiful craftsmanship and a sweet charm comparable to the ancient figures. There is also a Shino Oribe inkstone in the shape of a koto. This piece used to be in my possession, but it has since passed into other hands. It is of the highest standard and truly unusual.

Types of Shino
PLAIN SHINO *(muji Shino)*: This is solid white Shino ware with no deliberate patterns or pictures. A red color is often produced at the lip or at the corners of the pot where the iron content of the clay or the

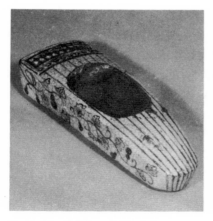

Koto-shaped Shino Oribe inkstone.

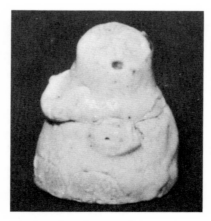

Monkey-shaped water dropper.

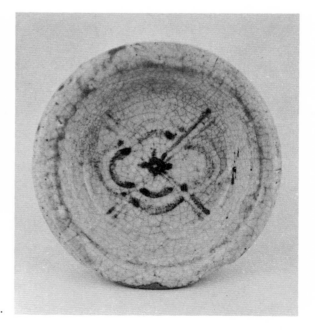

Picture Shino plate, cross design.

underglaze is only thinly covered by the feldspathic overglaze. Plain Shino was most common in the early period of Shino's history, but gradually came to be supplanted by decorated Shino. By the Genna era (1615–24), few plain Shino pieces were being made.

PICTURE SHINO *(e-Shino)*: Pictures are painted on the formed pot with a pigment made of the iron-and-manganese-rich *oni-ita* clay found in the region. Feldspathic glaze is then applied over the picture. The result is a black, red, or purple design that seems to float faintly up through the glaze.

Most favored were designs of grasses and flowers, fences, mountains, and geometric patterns. Christian influence can be recognized in the cross patterns occasionally used. In a few unusual cases, phrases from poems were painted on.

SHINO ORIBE: Shino Oribe is hard to separate from Picture Shino. The glaze of the former is perhaps a little thinner. The distinction is mainly chronological, with Shino Oribe being produced from the Genna era (1615–24) onward. If pressed to distinguish between the two, one might say the glaze of Shino Oribe shows a more pronounced shading of light and dark.

CRIMSON SHINO *(beni Shino)*: A slip made of red clay is used for decorating the surface of the pot. Over it a thin layer of feldspathic glaze is applied. The red that emerges in the firing is the same as that of Red Shino (see below), but the materials are different. Crimson Shino calls to mind a poem by the haiku poet Kyoshi:

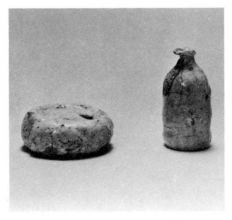

Miniature saké bottle and ink stick rest.

The white peony
Or so it's called, and yet
Crimson floats there faintly.

RED SHINO *(aka Shino)*: This is actually Gray Shino (see below) that has fired red because the feldspathic overglaze is thin and the kiln atmosphere has affected the iron-rich slip.

GRAY SHINO *(nezumi Shino)*: A slip of *oni-ita* clay is thickly applied to the surface of the pot, then a design is incised into it using a pointed bamboo or metal tool. The entire pot is then covered with feldspathic glaze. After firing, the pattern shows white, while the overglaze is gray. Occasionally the gray will have a faint purplish tinge—a highly-prized effect.

MARBLED SHINO *(neriage Shino)*: This technique is found only in teabowls from the Mutabora kiln at Ōgaya, and then only rarely. Even potsherds of this type are scarce. White clay and red clay are lightly mixed before throwing. After firing, the two types of clay show as white and black layers under the feldspathic glaze.

This technique was already being practiced in Tang and Song China. It is also found among pots from the Koryŏ dynasty in Korea, and this may have been the source for the Shino potters.

WHITE TENMOKU *(shiro tenmoku)*: This might be thought of as "pre-Shino Shino." Two White *Tenmoku* pieces said to have been originally owned by the tea master Takeno Jōō have been passed down through the Owari branch of the Tokugawa family and the Maeda family of Kaga. Both of the bowls have two or more ridges up through the body. The bowl in Plate 19 belongs to the author and was excavated in the vicinity of the Ōhira kiln. It might well be called Shino *tenmoku*.

Shino Clays; Shino Glazes
"Shino is the rough white clay of Mino; its glaze is pure feldspar to which a touch of silicic acid has been added." So says Tōkurō Katō.

"To make the Shino glaze, bars of weathered feldspar are ground into powder, then sifted. To this is added ash, clay, and a small amount of salt. Since this glaze does not adhere easily to clay, it is best to soak the pot thoroughly in it." This is Takuo Katō's description.

Toyozō Arakawa says, "The clay is wedged thoroughly. The materials for the glaze are careful-

ly ground into powder with a water mill. In the old days, the grinding was done by a foot- or water-powered mortar or by pounding with an oak mallet. The *oni-ita* clay used for the designs was also crushed by hand. A bit of silica-rich ash was added to the feldspar to make glaze. In the past, feldspar taken from the Kujiri region was used, but deposits of that mineral were scarce there. The mountains around Inkyo also yielded feldspar."

The late Hajime Katō (1900–68; designated a "Living National Treasure" in his lifetime) used to say that the feldspar from the Murakami area of Niigata Prefecture was best for Shino. And the late Kitaōji Rosanjin considered the feldspar from Wakasa, along the northern shore of Lake Biwa in Fukui Prefecture, to be of such fine quality that he brought it himself from there to his kiln in Kamakura.

The clay used for Oribe Shino would be best characterized as "moxa-type." I once saw a twenty-centimeter-thick vein of it at the ruins of an old kiln near Ōhira where *yamajawan* (prototeabowls made during the Kamakura and Muromachi periods) were once fired. To potters, good clay is one of the secrets of good pottery, and they keep a hawk's eye out for it.

This was made clear to me some years ago when I was riding the newly inaugurated bullet express train with Tōkurō Katō. He was staring out the window, and as the train sped past the base of Mt. Fuji, near Shizuoka, he suddenly said, "Now *there* is some fine clay!" His eyes were fixed hard on a certain spot.

The Value of Tea Ceramics and Shino Ware
While it is true that Kitaōji Rosanjin was known to have once planned a tea ceremony in which all of the utensils to be used were ones he had made himself, it is a general rule that the utensils chosen for a tea ceremony should not all be of the same kind. Thus even a tea host who is proud of his collection of Shino should not perform the ceremony using only Shino pieces. For example, if the ember holder in the ashtray in the guests' waiting area is made of Shino ware, then the water container or the teabowl used in the ceremony should be of some other ware, if one wishes to follow standard procedure. Since the combination of utensils used in a particular ceremony is taken to be representative of tea history and tea aesthetics, it is best to pick pieces that are suitable for the circumstances and not to be extravagant.

It would be a tea master's dream, perhaps, to use the teabowl named *U no Hanagaki* ("Fence of Deutzia Flowers"—Plates 2, 3) in a spring ceremony, or the teabowl *Yamanoha* ("Mountain Ridge"—Plate 10) or *Mine no Momiji* ("Summit Maple Leaves"—Plates 14, 15) in an autumn ceremony. Yet to marshall an array of famous pieces would leave the guests hard pressed to make appropriate praise. When I am serving tea, I pay careful attention to the guests who will come and I try to select utensils accordingly. I give particular thought to whether any of my Shino treasures will be used for the tea ceremony or accompanying formal meal.

Perhaps one does not aspire to such a classic water container as *Kogan* ("Weathered Shore"—Plate 1); rather, one seeks a change of pace in a modern water container by, say, Toyozō Arakawa or Tōkurō Katō. But nowadays even the pieces of these great contemporary masters have become so valuable as to be practically unobtainable.

An incense burner is supposed to be of subdued design and is placed unobtrusively in a corner of the *tokonoma* (a special alcove in the tea room). Yet a celebrated Shino incense box, barely large enough to fill the palm of one's hand, might nowadays fetch up to $50,000.

In the formal meal accompanying a full-dress tea ceremony, small serving dishes called *mukōzuke* play a central role. One such dish, if early Picture Shino or Gray Shino, can cost up to $10,000. Thus, a set of five—the usual number—would come to $50,000. Even a new Shino saké cup that would be used outside the tea ceremony can be sold for $3,000–$5,000. A classic piece is even more valuable.

The question is often asked, "Why are these utensils so expensive?" The only answer one can give is: "All tea articles are expensive." These pieces are not expensive because they are tea ceramics. The fact is that all ceramics are in some sense tea ceramics, whether they be folk pottery or pottery of the highest technical virtuosity (for the talented tea master can make use of anything). But it is undeniable that ceramics having a specific relationship with the tea ceremony are especially expensive.

If we imagine for just a moment that such a piece as the *Mine no Momiji* teabowl were put on the market, it would easily fetch over $200,000, even

in bad economic times. Ounce for ounce, such masterpieces are far more valuable than pure gold.

Simply stated, Shino ware is more expensive than Oribe ware, and Kiseto ware is more expensive than either one. Setoguro, while older as a pottery, is somewhat less valuable than Shino.

A piece of Shino, the price of which would have taken one aback ten years ago, will be worth three times that price not so many years from now. The cost of just one fine Shino teabowl is the same as that of a fine house.

Modern Shino Potters

In 1930, as Toyozō Arakawa was looking around old kiln sites at Mino, he found a Shino potsherd—a bit of a serving dish with a picture of a bamboo shoot painted on it. His discovery sparked a revolution in thinking about Momoyama pottery, for up to that time it had always been believed that Shino had only been made at the Seto kilns. Arakawa tells the story in his own words:

> The seeds for my discovery were sewn in the spring of 1930, when, through the good offices of Yokoyama Gorō of Nagoya, whose shop specialized in the finest tea ceremony articles, I was taken to the home of a certain wealthy family to view a Shino incense box and a Shino teabowl. There is no need to go into detail regarding the circumstances leading up to my seeing the teabowl, but at least some small description of the bowl would be in order. It was large and cylindrically shaped,

as is often the case with Kiseto teabowls. A narrow *dōhimo* line had been pinched outward around the center. Soft, snowlike Shino glaze covered the entire pot, here thick, there thin. And in places a scarlet of rich tone had emerged naturally. Two bamboo shoots, one large and one small, had been artlessly painted onto the cylinder as if to illustrate the lines of the poem "on gently sloping mountainside/two or three pines." Inside the foot, there was a distorted red circle—the mark of a fireclay pad. It was a gentle pot, with a distinctly Japanese air.

Up till that time, I had always been enamored of Chinese or Korean pottery and had tried to emulate it. Of Japanese styles, I had only tried my hand at Old Kutani. But I was deeply moved by this peculiarly Japanese Shino bowl and I gazed long and hard at it as if to devour it with my eyes.

Suddenly my eye was caught by a tiny red speck barely half the size of a grain of rice. It was a bit of red clay stuck to the inside of the foot—a remnant from the fireclay ring. It had long been claimed that Shino ware had originally been fired at the kilns at Seto, in Owari, but this tiny bit of clay stuck to the Shino bowl did not seem to be the kind of clay one might find around Seto. Thus I began to have doubts about the tradition that Shino came from there.

That night I could not sleep as I turned these doubts and their implications over in my mind. I remembered how in 1923 or 1924 I had come

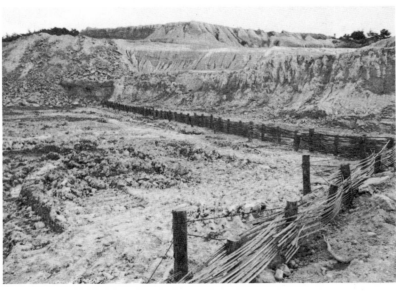

Clay quarry, Kani-machi.

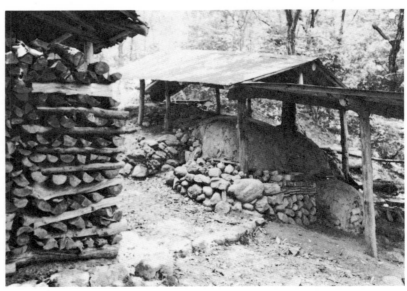

Toyozō Arakawa's kiln.

from Kyoto to look into the old Mino kilns. Digging at the old kiln site at Ōhira, I had only found shards covered with black *tenmoku* or amber-colored iron glaze. On the way back, I had found a fragment of a green Oribe pot and, thinking it was an odd thing to find there, I had taken it home with me. Looking back on that, I began to wonder if maybe Shino ware had not actually been fired at Mino.

I felt I had to go there and find out as soon as possible. Waiting for the sun to come up was agony. Early the next morning, I took the first train to Tajimi, and since there were no cars in Tajimi in those days, I stayed the night there.

The next day, before dawn, I followed the directions a local man had given me and started out along a mountain road in Takada—the same road I had walked some years before. After a mile or so I came to that same old kiln site, and I quickly began to dig. But again I only found bits of black *tenmoku* and amber-glazed shards. There was nothing even faintly resembling Shino.

I was a little disappointed, but the sun was still high in the sky, so I decided to go on to the kiln site at Ōgaya. I had never been beyond Ōhira before, but I followed the one road that led between the two mountains and after about two kilometers I arrived at Ōgaya. At Ōhira there were only four or five houses perched here and there on the mountainside, and the mood was quite lonely. But at Ōgaya, even though there were only five or six houses, too, tucked into the mountains, the atmosphere was bright and tranquil.

Having asked directions from an old villager, I made my way to what looked like an old kiln site in a forest of cedars and other trees in the valley of Mutabora. Sifting through the shards I discovered among the pieces of *tenmoku* black a shard with Shino glaze on it. Looking at it carefully I could hardly believe my eyes, for it was exactly like the teabowl I had seen two days earlier, even down to the design of bamboo shoots in red! Almost doubting my sanity, I continued to dig as though in a dream. Next I found a fragment of a large bowl done in what is commonly called "Gray Shino." Its

glaze was just like that of the incense box I had been shown along with the teabowl. I realized that I had run across something very important indeed. I am afraid I am just not good enough with words to describe how I felt at that moment.

From the *Sekai tōji zenshū* ("Pottery of the World"), Monthly Report 8.

Arakawa's discovery set off a spate of kiln excavations, first by Rosanjin Kitaōji and Tōkurō Katō. Soon thereafter, teams sponsored by major newspapers and led by such men as Ken'ichirō Ono, Kichijirō Inoue, and Nagatake Murayama also joined in. The pastures around Tajimi proved to be a treasure trove of valuable artifacts.

In recent years there has been a boom in the collecting of tea ceramics. For this a debt is owed to the great masters Toyozō Arakawa and Tōkurō Katō and the hardships they endured before the war in their pursuit of Momoyama pottery.

The dramatic rise in demand for tea ceremony ceramics has been a blessing for potters. Shino ware has proved particularly popular, and now over one hundred potters make this ware.

Space limitations have prevented discussion of more than the work of a few potters in these pages, yet the scale of the Shino operation is quite large. Starting with the village of Akatsu, favored by artisans in the 1910s and twenties, potters are concentrated in a wide bank centering on Tajimi, where many of the Momoyama and Edo period kilns used to be. In terms of size, this "pottery village" far surpasses the much vaunted one at Seto.

At Mutabora in Ōgaya a group of potters working in the traditional style has gathered under the leadership of Toyozō Arakawa. Using a traditional semiunderground kiln that they built themselves, this group truly represents a modern Momoyama revival.

In contrast to the nameless potters of old, who probably led a hand-to-mouth existence, many present-day artisans are strikingly wealthy. Tōkurō Katō has wryly noted that "what potters of today create is homes for themselves."

Nevertheless, there remain many potters of good faith. For their sake it is sad that there are so many undiscriminating people who like anything called Shino regardless of what it is or who made it.

Shino Miscellany

The piece named *U no Hanagaki* ("Fence of Deutzia Flowers"—Plates 2, 3) is considered the finest of all Shino teabowls. Others include: *Asahagi* ("Morning Bush Clover"), *Asahi* ("Morning Sun"), *Mine no Momiji* ("Summit Maple Leaves"—Plate 13), *Yama no Ha* ("Mountain Ridge"—Plate 10), *Sazanami* ("Ripples"), *Hatsune* ("The Bush Warbler's First Spring Song"), *Hirosawa* ("Wide Marsh"), *Yūmomiji* ("Evening Maple Leaves"), *Sumiyoshi* ("Sumiyoshi"; a place name), *Tsūten* ("The Maple Leaves at Tsūten Bridge"), *Kasugano* ("The Field at Kasuga"), *Hashihime* ("The Lady at the Bridge in Moonlight"), *Senkoku* ("One Thousand Measures of Rice"), *Hagoromo* ("Feather Cloak"—Plate 18), *Mōko* ("Fierce Tiger"), *Ushiwaka* ("Young Minamoto no Yoshitsune"), *Yokogumo* ("Bank of Clouds"), *Matsushima* ("Pine Islands"—Plate 21), and *Asahikaga* ("Morning Sunlight"). These and other fine bowls are hidden away in the mansions of famous collectors of tea ceramics, and rarely is there opportunity to see them.

The complete teabowl experience can only be had by actually holding the bowl in the palm of one's hand and putting one's lips to its rim to drink the tea. Though this experience has been written about in countless books, it can never be completely described. The pleasure it brings is like a dream.

I have had the chance to see firsthand the teabowls *U no Hanagaki* and *Mine no Momiji*, and I shall never forget the powerful emotions I felt at the time.

The *Taishō meikikan* ("Famous Ceramics of the Taishō Period") says this about *U no Hanagaki*: "Its lip is rounded at the rim and even in thickness. A reddish tinge suffuses the white glaze that covers the entire body. Dark crosshatches have been faintly drawn on the sides in a manner that suggests a woven fence. Cloud-white glaze surrounds and partially obscures this design, giving the impression of white deutzia blossoms—hence the name, "Fence of Deutzia Flowers."

The book goes on to say, "The grace of this deep teabowl is eloquent testimony to the skills of the potter who made it."

The teabowl *Hatsune* ("The Bush Warbler's First Spring Song") was once featured at a lecture given by a local chapter of the Nihon Tōji Kyōkai (Japan Pottery Association). The firing of this bowl produced a subtle, plum-red cast on the white surface. Looking at it, one could almost hear the first spring song of a bush warbler perched on a plum branch. Nowadays, this teabowl would never be lent out to some regional group, but until 1955 such a thing was conceivable.

Around 1965, the teabowl *Mine no Momiji* was put on display. We were not allowed to touch the bowl, which was set on a purple cloth, but we could see it from all four sides. The restrictions placed on the viewing were cruel indeed, for to feel that bowl resting in the palm of one's hand surely would have been a more meaningful encounter with Truth. It was like having an itch one could not scratch.

In my own collection there is a cylindrical serving dish with willow and bush clover design, made at the Ōgaya kilns (see Plate 26). I discovered one just like it at an inn called Nandaimon in Nara. The owner of that inn, the father of an old acquaintance of mine, made a practice of displaying his favorite art possessions in the lobby of the establishment, and it was there that I saw the dish exactly like mine.

Supposing those pieces were made around 1605, what joys and sorrows, what vicissitudes, must these two pots have seen since they left the Ōgaya kilns some 380 years agō The innkeeper and I passed hours in such speculation. For all that they must have passed through, these pots seemed none the worse for it.

We wondered if the innkeeper's pot looked the way it did precisely because it had been through good times and bad. Or perhaps, we conjectured, it might have benefited from supernatural protection, or the loving attention of some tea master.

In the case of my serving dish, I know that it was kept by several tea masters in Kanazawa and did not see much of Edo period Japan. But the innkeeper's pot—what kind of journey did it make through history? And what will happen to it in the future? Such are the emotions, the feelings of attachment, that a single Shino piece can generate.

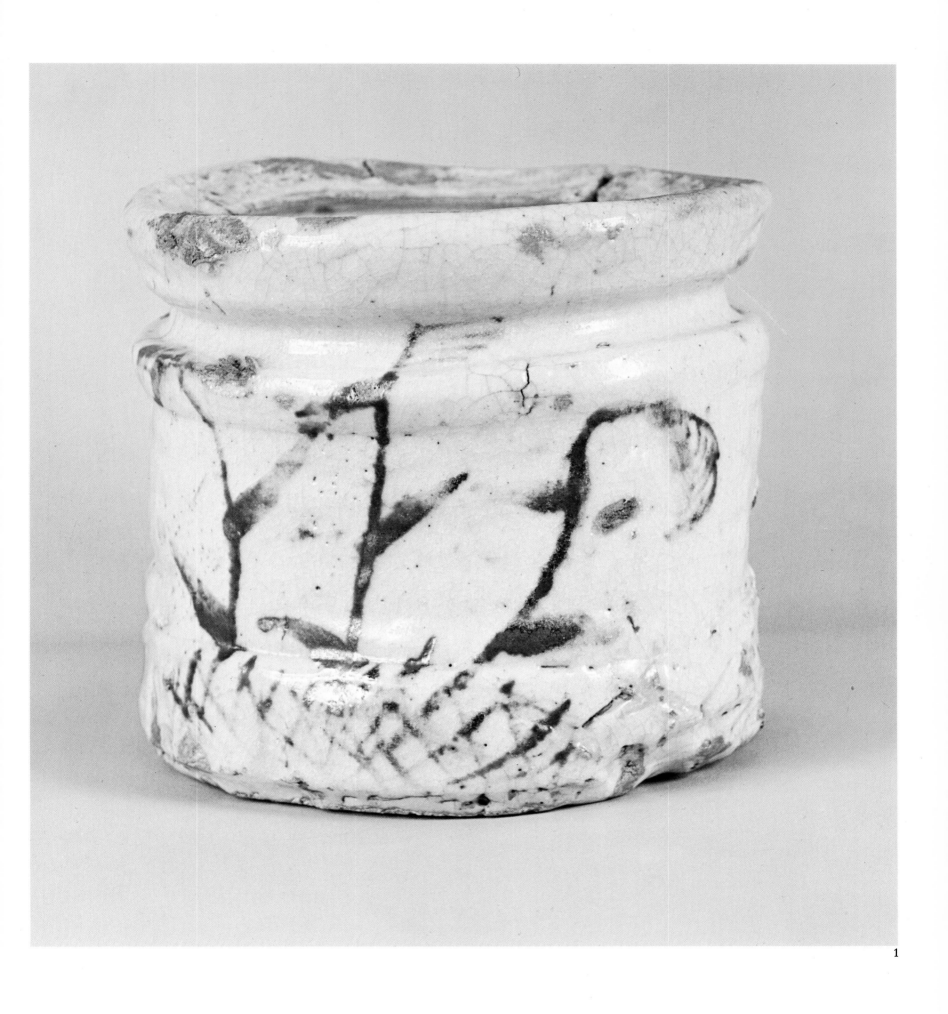

1. *Picture Shino water container, name: Kogan ("Weathered Shore"). H. 18.0 cm. Important Cultural Object. Hatekeyama Collection.*

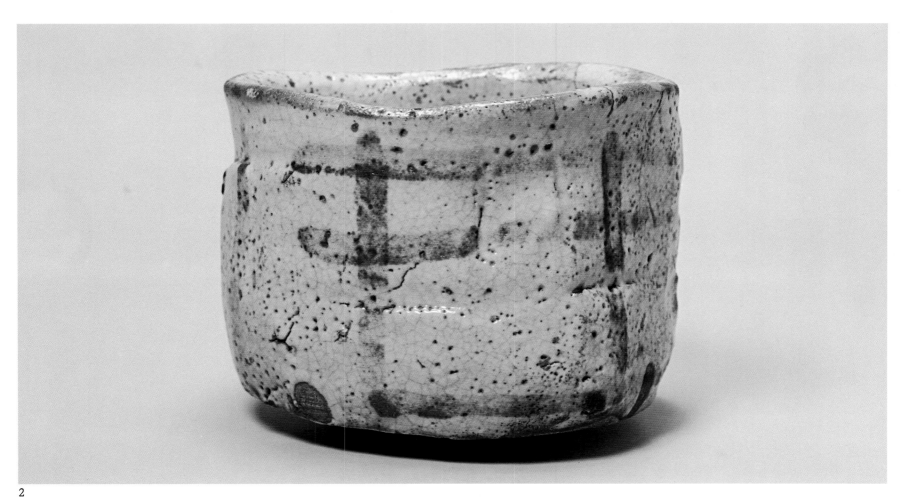

2

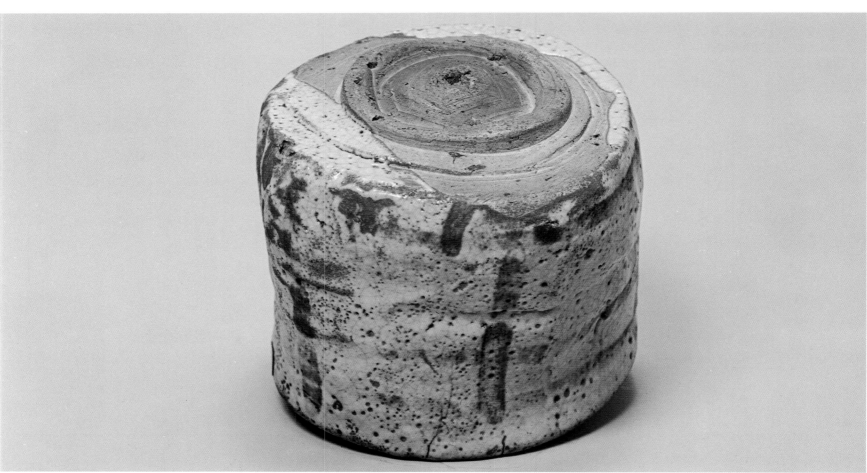

3

2, 3. *Picture Shino teabowl, name:* U no Hanagaki *("Fence of Deutzia Flowers").*
D. 11.8 cm. National Treasure.

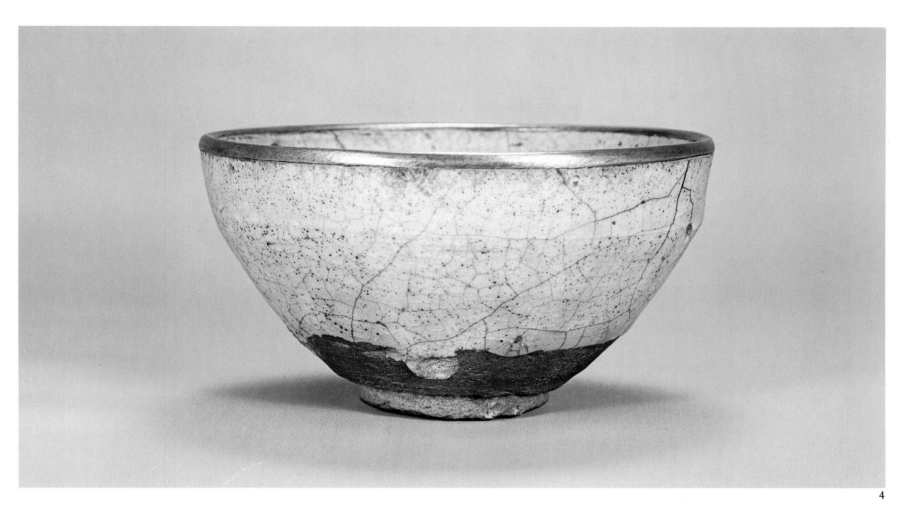

4

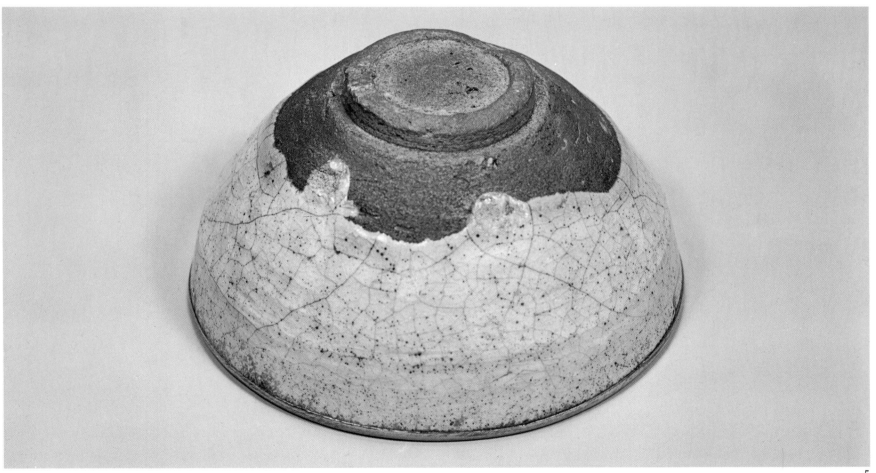

5

4, 5. *White* Tenmoku *teabowl. D. 12.3 cm. Important Cultural Object. Tokugawa Reimeikai Foundation.*

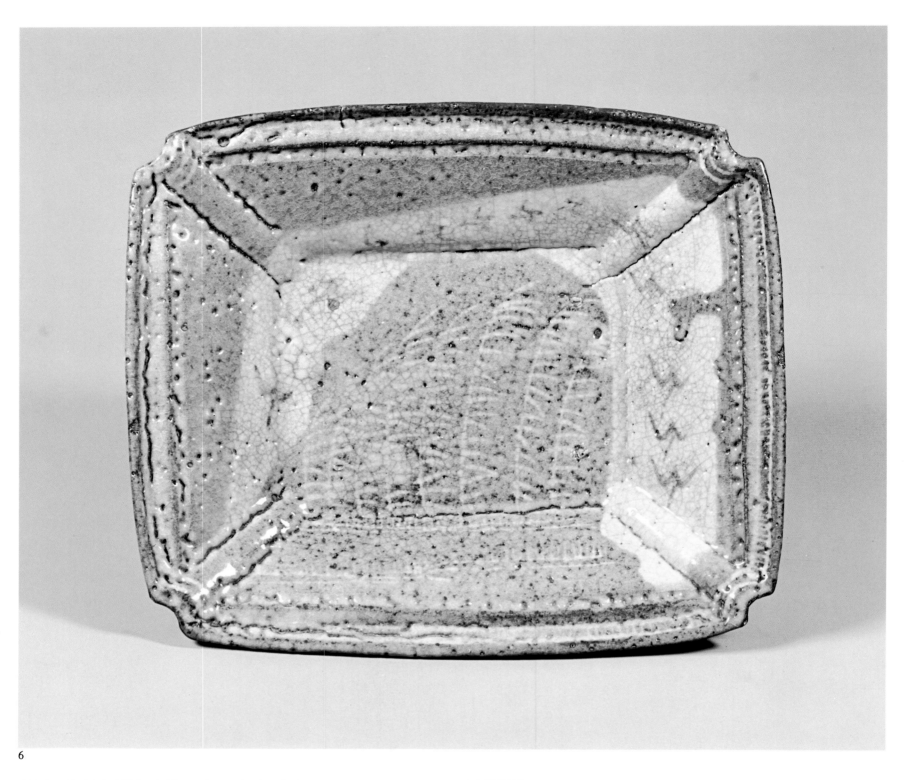

6

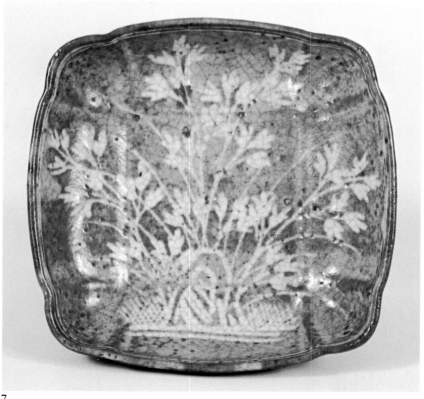

7

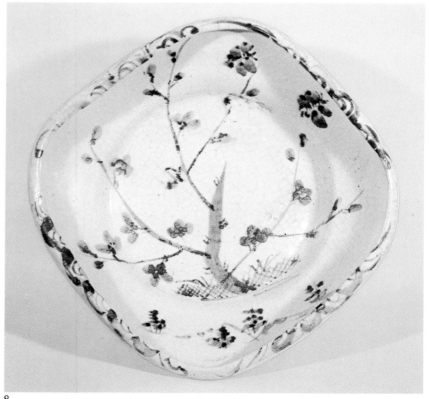

8

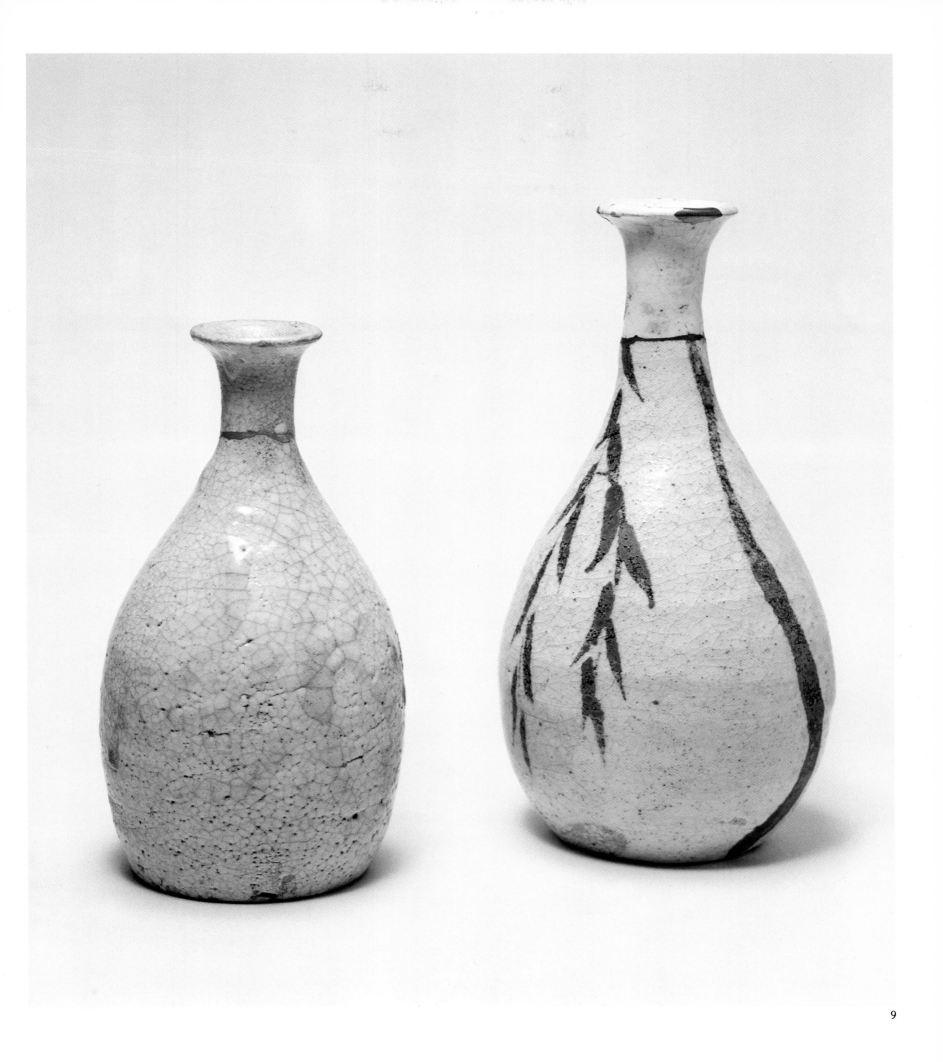

9

6. *Gray Shino, "picture frame" shallow dish, design of grasses and flowers. W. 23.7 cm. Umezawa Memorial Gallery.*

7. *Gray Shino serving dish, design of grasses. W. 16.0 cm. Hakone Museum of Art.*

8. *Picture Shino bowl, design of flowering plum branches. W. 26.9 cm. Hakone Museum of Art.*

9. *Plain Shino saké bottle; Shino Oribe saké bottle. Left: H. 17.5 cm. Right: H. 18.0 cm.*

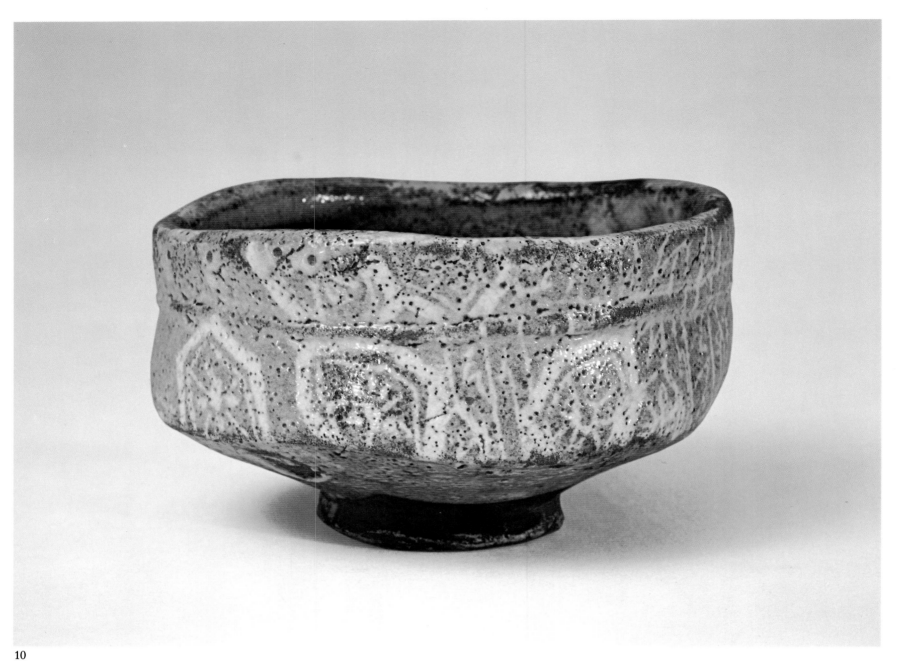

10

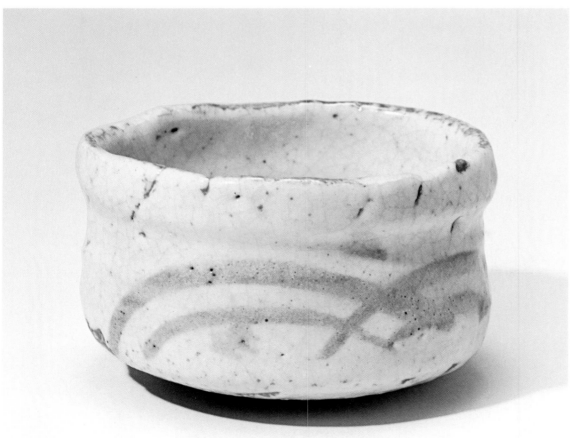

12

10. *Gray Shino teabowl, name:* Yama no Ha *("Moutain Ridge"). D. 13.3 cm. Nezu Art Museum.*

11, 12. *Picture Shino teabowl. D. 13.5 cm.*

11

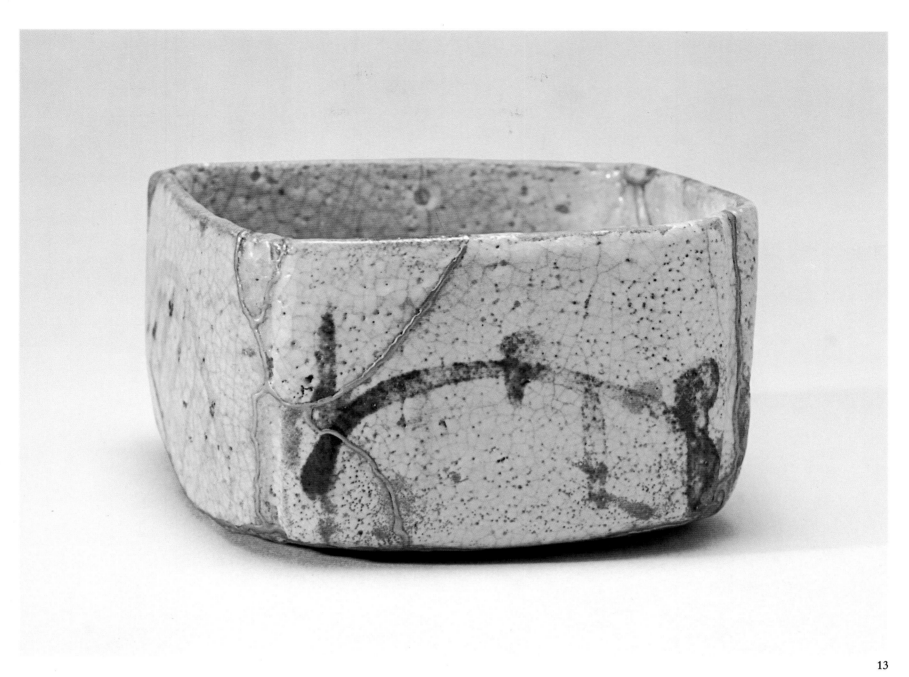

13

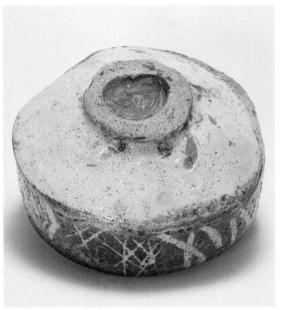

14

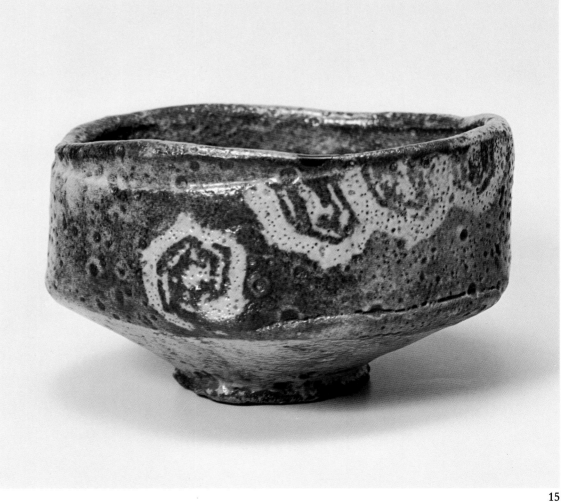

13. *Shino serving dish, repaired. H. 6.8 cm.*

14, 15. *Gray Shino teabowl, name:* Mine no Momiji *("Summit Maple Leaves"). D. 13.6 cm. Gotō Art Museum.*

15

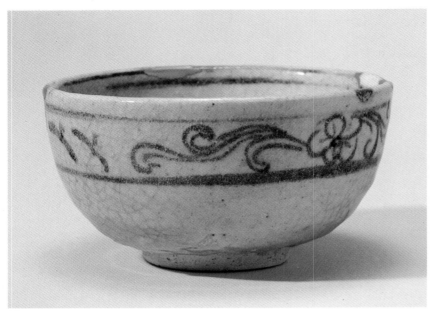

16

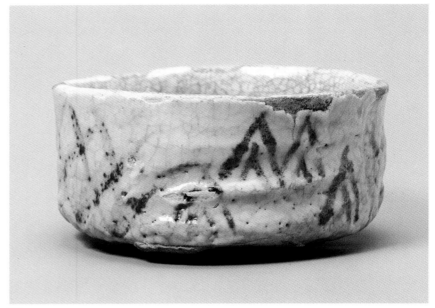

17

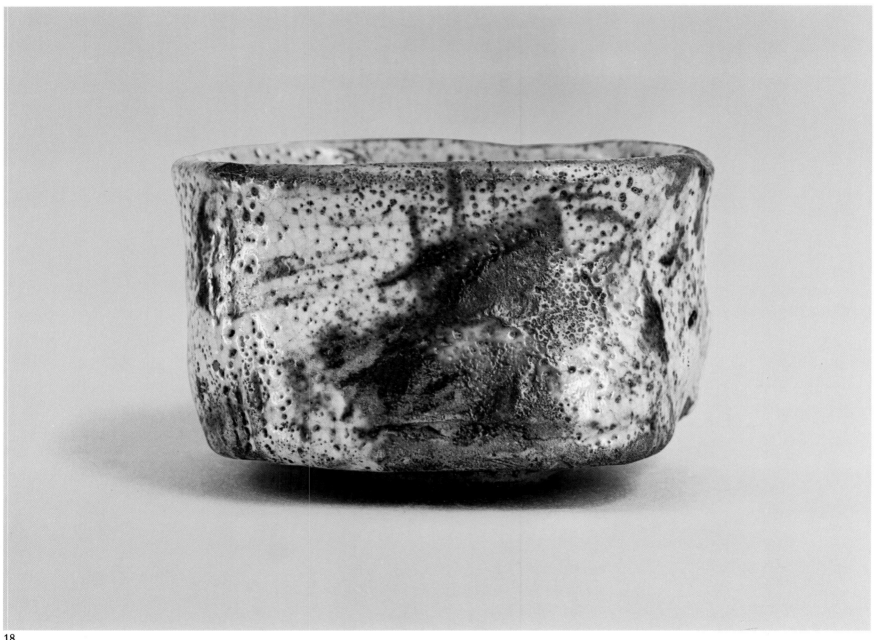

18

16. *Picture Shino teabowl. D. 11.8 cm.*

17. *Picture Shino teabowl. D. 18.0 cm.*

18. *Shino teabowl, name:* Hagoromo *("Feather Cloak"). D. 13.4 cm.*

24

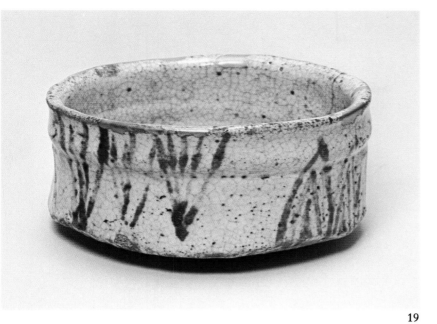

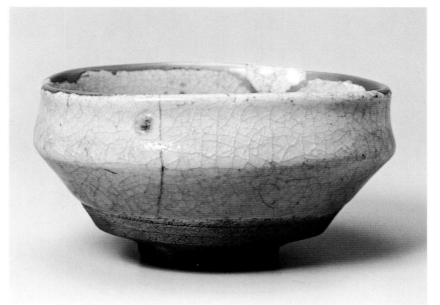

19

20

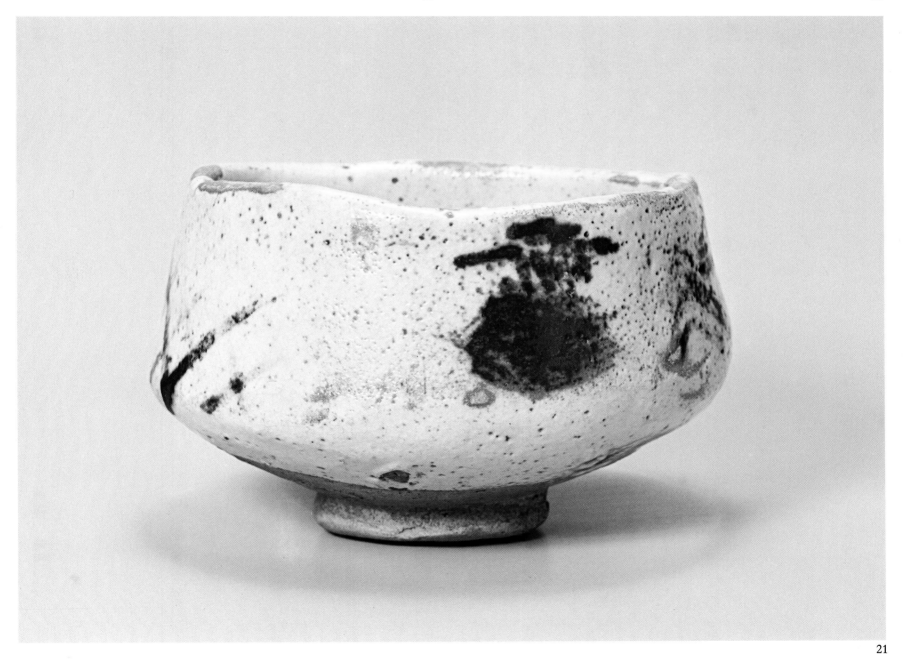

21

19. *Picture Shino teabowl. D. 13.4 cm.*

20. *Shino* tenmoku *teabowl. D. 12.0 cm.*

21. *Picture Shino teabowl, name:* Matsushima ("Pine Islands"). *D. 13.0 cm.*

25

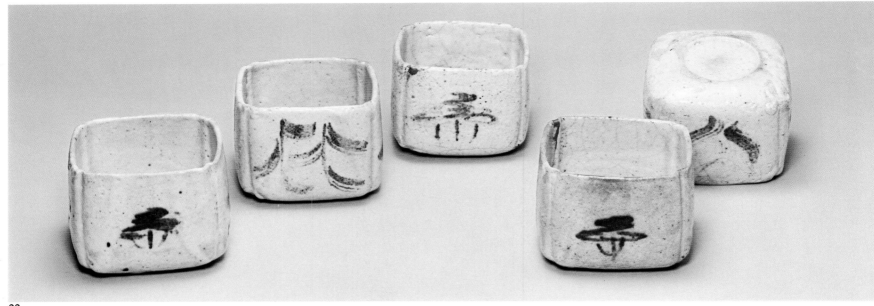

22

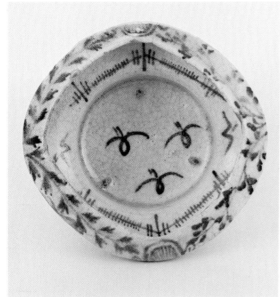

23

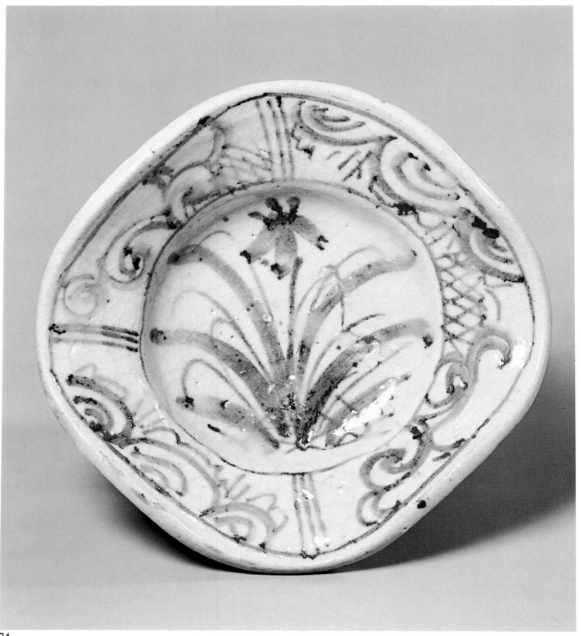

24

22. *Picture Shino, small serving dishes (mukōzuke), four-sided with pinched-in corners. H. 6.8 cm.*

23. *Picture Shino bowl, design of flying birds. D. 16.8 cm.*

24. *Picture Shino serving dish, design of iris. D. 19.0 cm.*

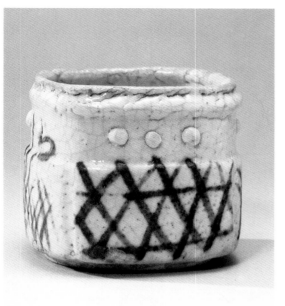

25

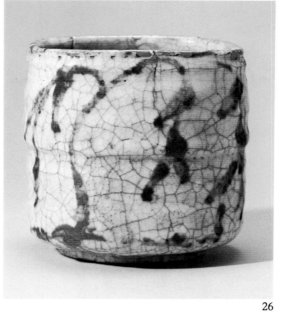

26

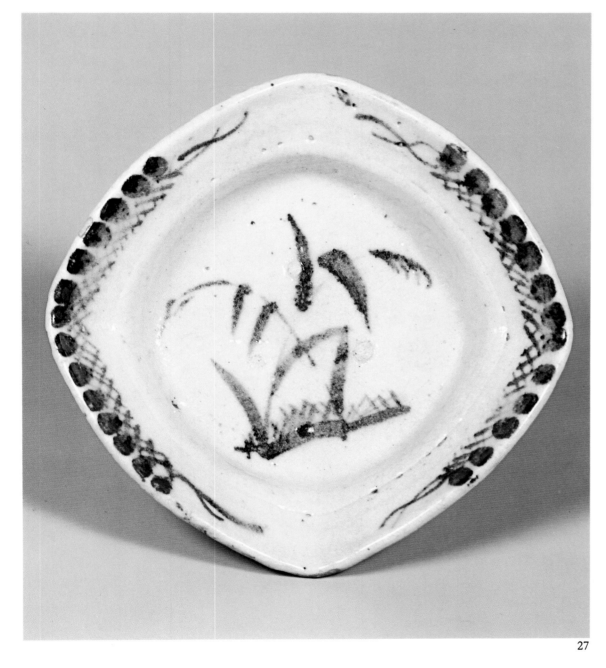

27

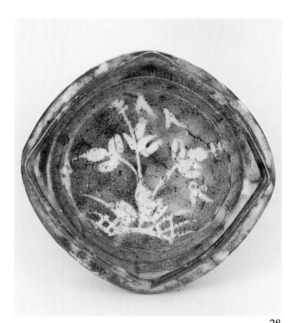

28

25. *Deep serving bowl, protruding decorations. H. 8.1 cm.*

26. *Picture Shino, cylindrical serving dish, design of willow and bush clover. H. 9.7 cm.*

27. *Picture Shino serving dish, design of pampas grass. D. 16.8 cm.*

28. *Gray Shino serving dish, design of grasses and flowers. D. 17.2 cm.*

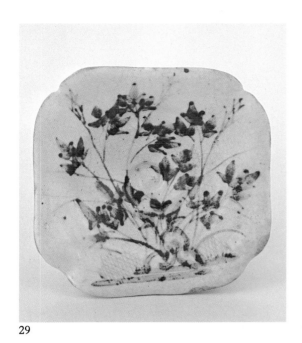

29

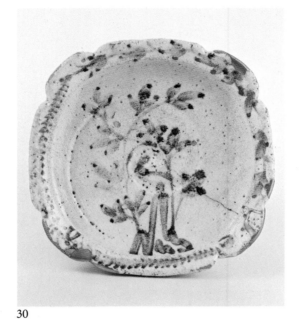

30

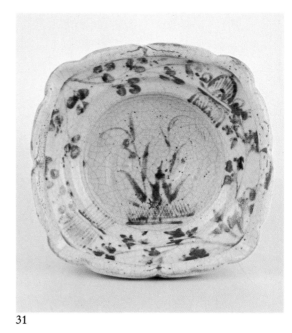

31

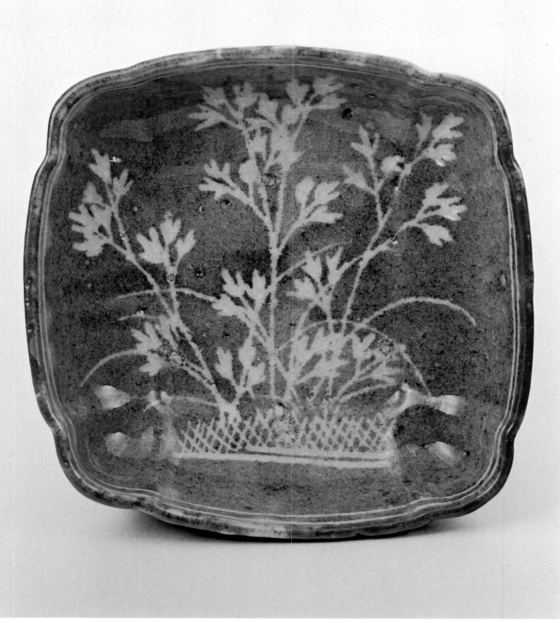

32

29. *Picture Shino serving dish, design of autumn grasses. W. 15.8 cm. H. 4.7 cm.*

30. *Picture Shino serving dish. W. 15.8 cm. H. 5.5 cm.*

31. *Picture Shino serving dish. W. 15.4 cm. H. 6.3 cm.*

32. *Gray Shino serving dish, design of grasses. W. 16.0 cm. H. 6.0 cm.*

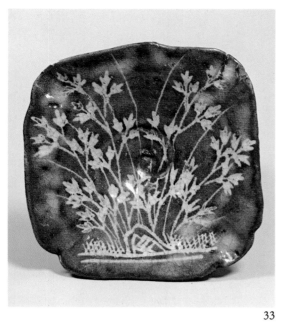

33

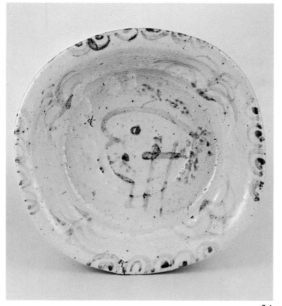

34

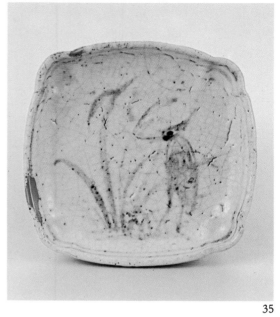

35

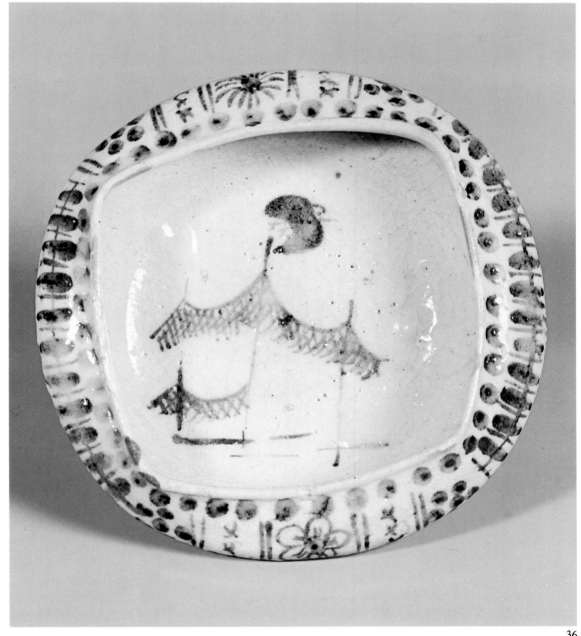

36

33. *Gray Shino bowl, design of grasses. W. 15.9 cm. H. 3.6 cm.*

34. *Picture Shino bowl, protruding decorations. D. 23.8 cm. H. 8.0 cm.*

35. *Picture Shino serving dish, design of heron. W. 16.4 cm.*

36. *Picture Shino small four-sided bowl. D. 15.4 cm. H. 6.0 cm.*

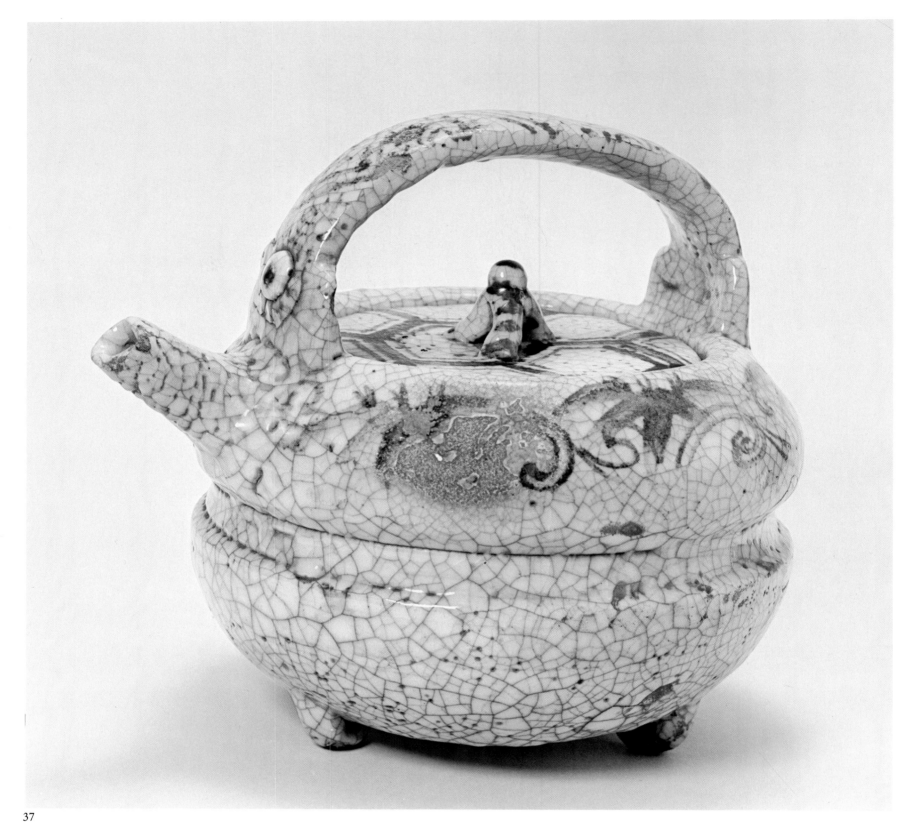

37

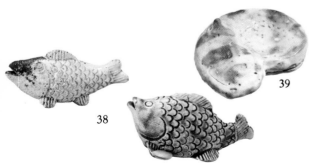

38

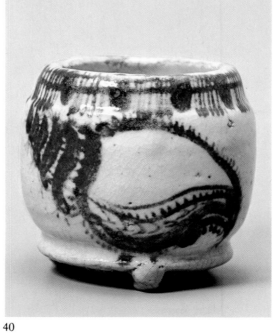

39

40

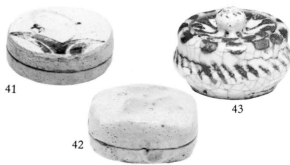

41

42

43

37. *Shino Oribe saké server. H. 18.0 cm.*

38. *Plain Shino fish-shaped water dropper; Green Oribe fish-shaped water dropper. L. 10.6 cm.*

39. *Gray Shino catfish-shaped incense box, designed by Seison Maeda. L. 6.2 cm.*

40. *Picture Shino ember holder, design of shellfish. H. 8.5 cm.*

41. *Picture Shino incense box. D. 6.0 cm.*

42. *Plain Shino incense box, by Toyozō Arakawa. H. 3.2 cm.*

43. *Picture Shino incense box. H. 4.5 cm.*

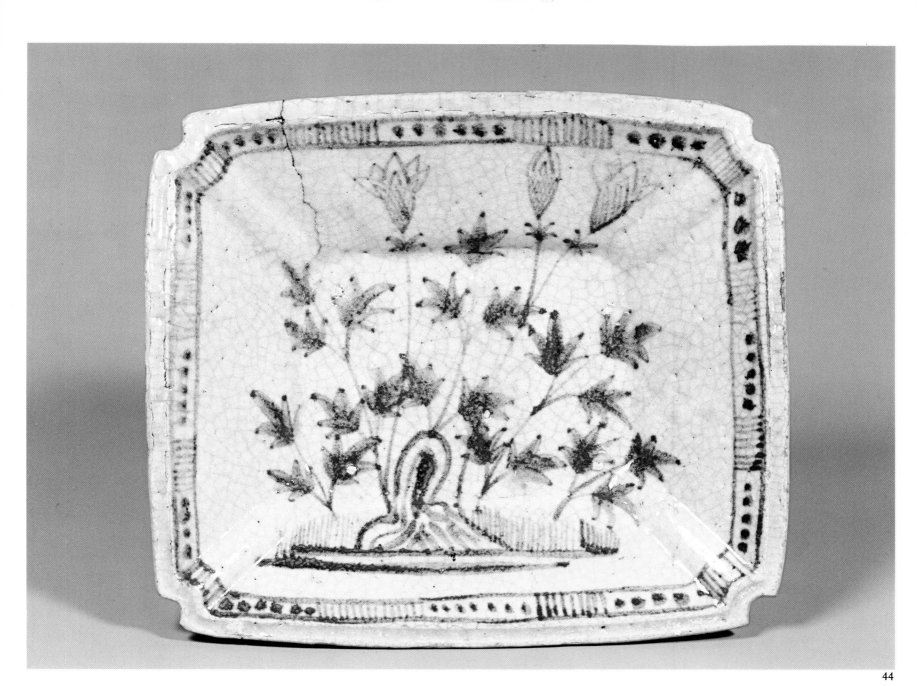

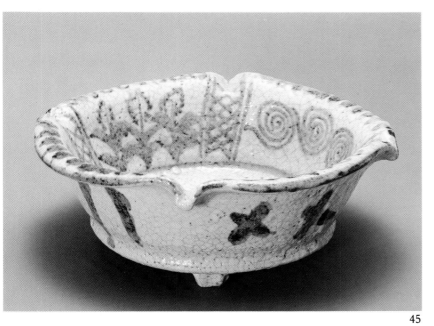

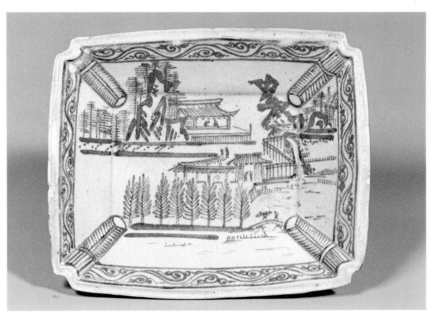

44. *Picture Shino "picture frame" bowl, design of grasses and flowers. W. 13.0 cm. H. 5.0 cm.*

45. *Picture Shino deep bowl, design of grasses and flowers. H. 18.0 cm.*

46. *Picture Shino "picture frame" bowl, design of Chinese buildings and human figures. W. 15.2 cm. H. 3.9 cm.*

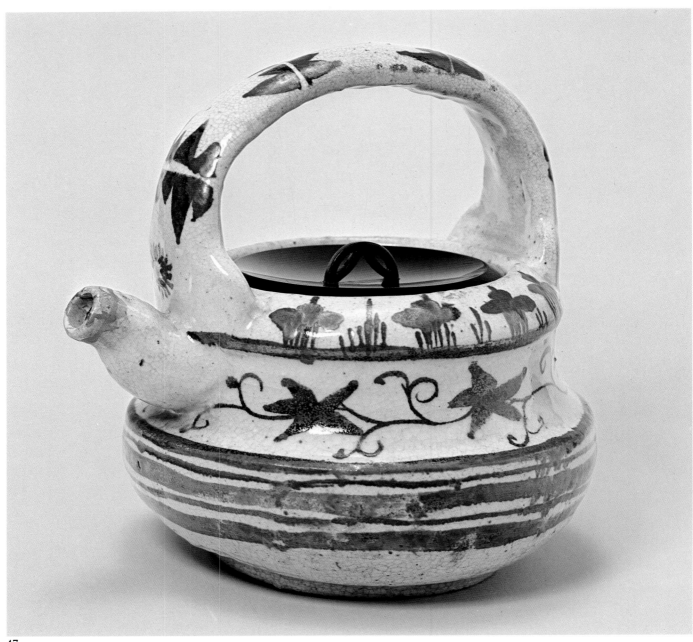

47

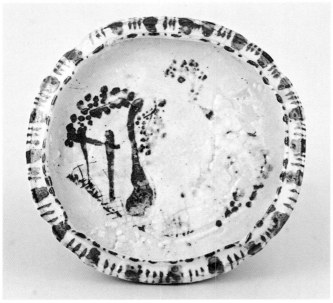

48

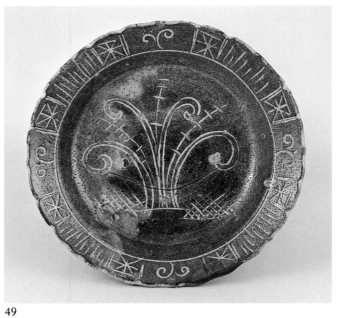

49

47. *Shino Oribe saké pot. H. 16.8 cm.*

48. *Picture Shino shallow bowl. W. 24.8 cm. H. 5.0 cm.*

49. *Gray Shino bowl, bracken fern design. D. 26.2 cm. H. 5.7 cm.*

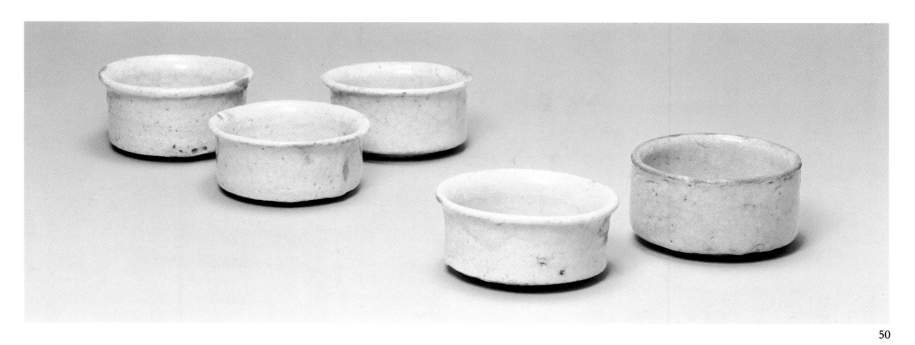

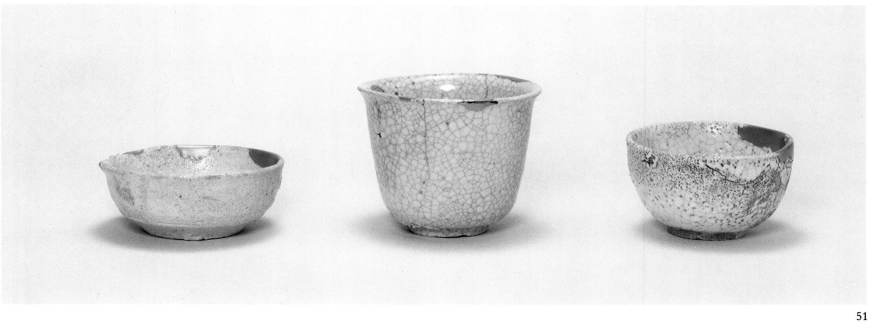

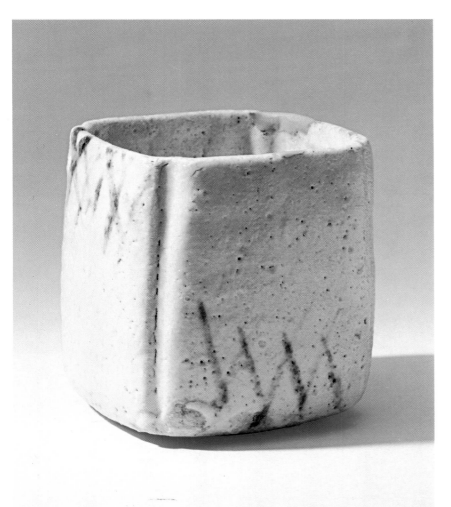

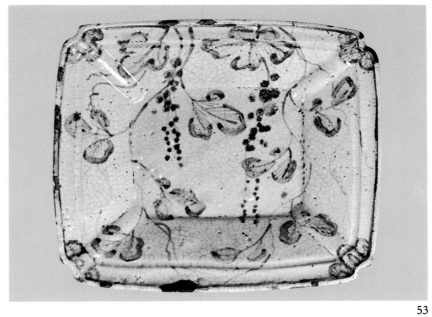

50. *Plain Shino saké cups. D. 7.1 cm. H. 4.0 cm.*

51. *Plain Shino saké cups. Left: D. 6.5 cm. Middle: D. 6.8 cm. Right: D. 5.9 cm.*

52. *Picture Shino deep, square serving dish (mukōzuke). H. 7.0 cm.*

53. *Picture Shino "picture frame" bowl, design of wild grapes. W. 24.0 cm. H. 5.1 cm.*

50

51

53

52

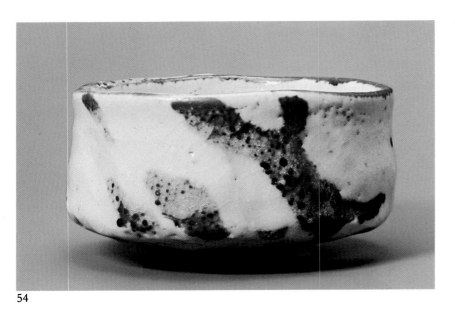

54

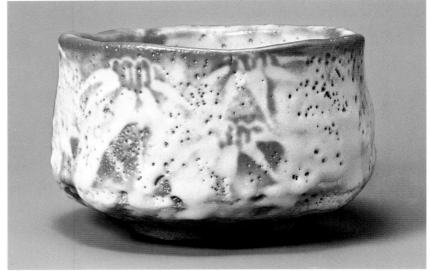

55

CONTEMPORARY SHINO WARE

54. *Picture Shino teabowl, by Shuntō Katō. D. 12.9 cm.*

55. *Red Shino teabowl, by Seizō Katō. D. 13.1 cm.*

56. *Picture Shino teabowl, by Osamu Suzuki. D. 13.4 cm.*

57. *Plain Shino teabowl, by Seisei Suzuki. D. 13.0 cm.*

58. *Picture Shino teabowl, by Hidetake Andō. D. 13.1 cm.*

59. *Picture Shino teabowl, by Kōzō Katō. D. 12.6 cm.*

60. *Plain Shino teabowl, by Yasuo Tamaoki. D. 13.2 cm.*

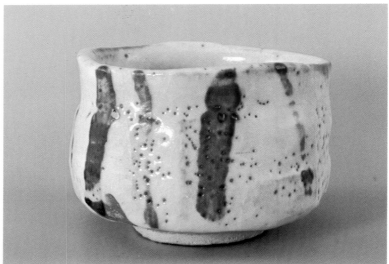

56

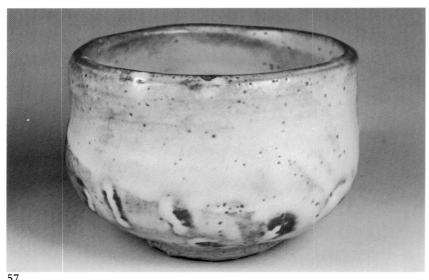

57

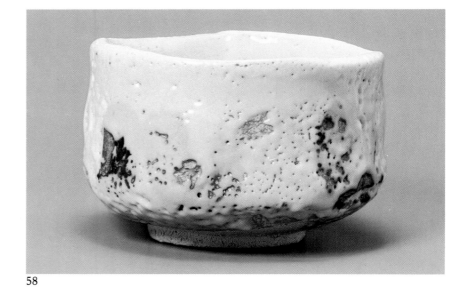

58

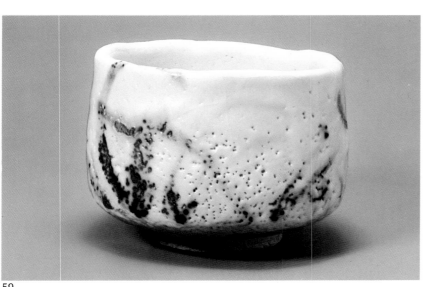

59

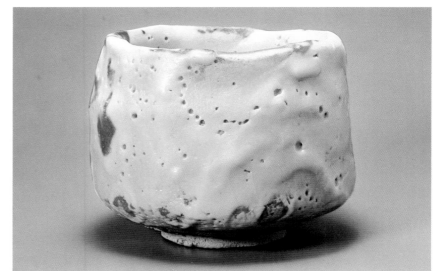

60

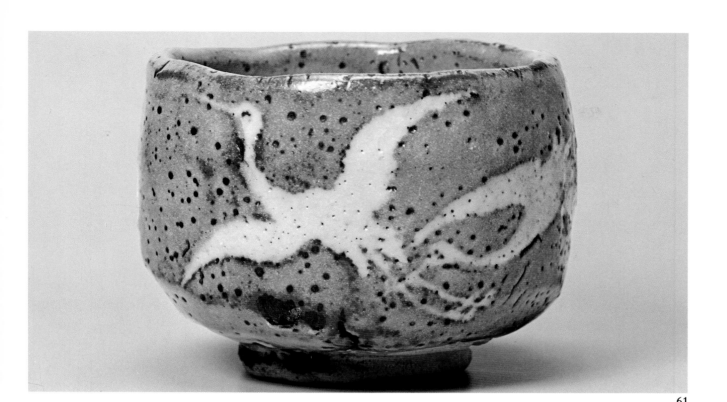

61

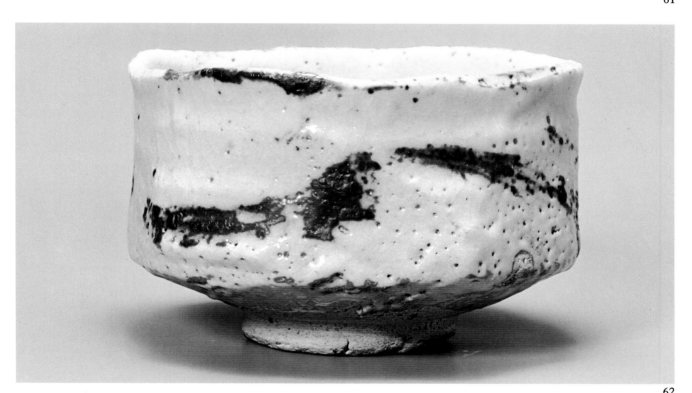

62

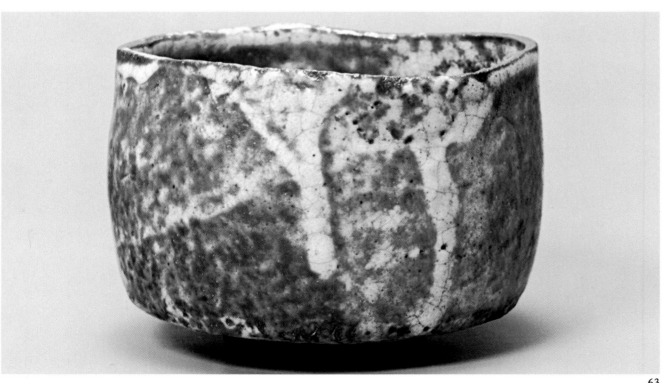

63

61. *Gray Shino teabowl, design of flying cranes, by Toyozō Arakawa. D. 12.8 cm.*

62. *Picture Shino teabowl, by Tōkurō Katō. D. 14.2 cm.*

63. *Gray Shino teabowl, by Rosanjin Kitaōji. D. 10.8 cm.*

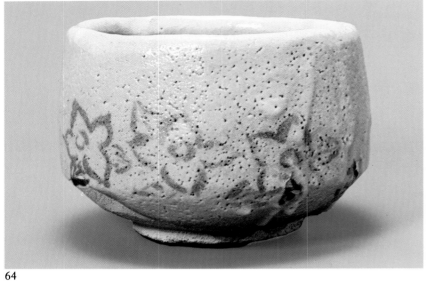

64

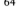

65

66

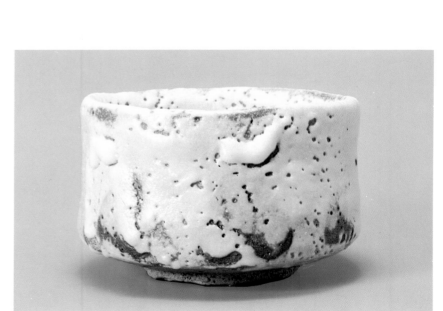

68

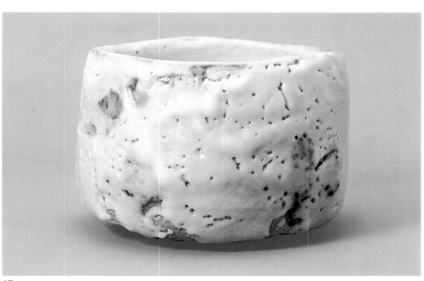

69

67

64. *Picture Shino teabowl, design of Chinese bellflowers, by Naoki Nakayama. D. 12.7 cm.*

65. *Gray Shino teabowl, by Takuo Katō. D. 12.8 cm.*

66. *Picture Shino teabowl, by Kōtarō Hayashi. D. 13.1 cm.*

67. *Plain Shino teabowl, by Kenji Kishimoto. D. 12.5 cm.*

68. *Gray Shino teabowl, by Toshisada Wakao. D. 13.7 cm.*

69. *Plain Shino teabowl, by Shuntei Katō. D. 12.0 cm.*

Plate Notes

In a good piece of Shino, brown tinged with a pleasing red suffuses the white ground. To see this is to know joy.

−*Kitaōji Rosanjin*

1. *Picture Shino water container, name:* Kogan *("Weathered Shore"). H. 18.0 cm. Important Cultural Object. Hatakeyama Collection.*

There are not many Old Shino water containers to be found in Japan. The most famous of this elite group is the piece known as *Kogan.* It was probably fired at the Ōgaya Kamashita kiln at the beginning of the seventeenth century.

Its bottom edge (*tatamitsuki*) is extremely powerful. The lip has been notched, and the neck squeezed in with mathematical, almost frightening, precision. One might mistakenly assume that Furuta Oribe had a hand in this piece, as it is very much in the style he espoused. There is nothing incomplete about it.

The continuous design on the pot is not itself unusual, but here the execution is grand. It is hard to believe that it was done by a potter. Kitaōji Rosanjin has said that it is not necessary to stare long and hard at the pictures drawn by Momoyama potters. This jar is a wonderful example of that principle.

The color of the feldspathic Shino glaze is especially fine. The design—it is difficult to tell whether it is of reeds or pampas grass—is lively.

It seems to have been thrown rather casually, omitting fine details. It owes much of its effect to the events that occurred during firing: *ishihaze* ("stone bursting"—pits caused by the melting of feldspar granules in the clay) and cracks by the heat.

It is not known who named the pot *Kogan*, but one can imagine that the lonely name was inspired by a cold, late autumn wind blowing off the mountains.

2, 3. *Picture Shino teabowl, name:* U no Hanagaki *("Fence of Deutzia Flowers"). D. 11.8 cm. National Treasure.*

This bowl is said to have originally been in the possession of the Fuyuki family, apparently one of Tokyo's most prosperous houses in the Edo period. From Tokyo, the bowl came into the hands of the Yamada Hachirōbei family of Osaka. Subsequently, according to the *Taishō meikikan*, it was sold at a Kyoto auction in 1890 for the sum of 1,000 yen in gold. Now it belongs to the Mitsui family.

Given the fact that there are virtually no other teabowls

in Japan that have been designated National Treasures, it seems safe to say that this is the finest teabowl in existence.

The inscription on the box lid is attributed to the tea master Katagiri Sekishū. On the inside of the lid a poem card has been affixed with a poem that reads:

> The inner essence
> Of the fence of deutzia flowers
> In a mountain village:
> The feeling of treading a road
> Covered with freshly fallen snow.

It is not certain who wrote this poem, but the style of calligraphy is one at which Sekishū excelled, so some think that this poem is his as well.

The bowl was fired at the Ōgaya Mutabora kiln. Its irregular shape is indescribably elegant. The glazing, too, is superb. The red at the lip, caused by the fire in the kiln, and the flowing design, are especially beautiful.

There is another teabowl, called *U no Hana* ("Deutzia Flowers"), done in the same style. The late Fujio Koyama reported in a journal article that a third companion piece, a bowl with pine tree design, turned up in Kanazawa.

It has been established that Katō Genjūrō Kagenari was the founder of the kilns at Ōgaya. And while the claim made by some that this bowl is one of his works may well be true, it seems strange that this should be the only known example of his pottery. A brown-glazed tea caddy attributed to him has been passed down through generations of the Konoe family, but only the Konoe family regards this as authentic. Genjūrō may in fact have made this tea caddy and the *U no Hanagaki* teabowl, but these attributions are traditional and cannot be proven.

4, 5. *White* Tenmoku *teabowl. D. 12.3 cm. Important Cultural Object. Tokugawa Reimeikai Foundation.*

This is a dignified White *Tenmoku* teabowl lined with gold at the rim. (The *tenmoku* term comes from the utensils used at a Buddhist temple on Mt. Tenmoku—Tianmu in Chinese—in China's Zhejiang Province.)

Judging from the way the foot was trimmed, the bowl is thought to have been made sometime in the Tenshō era (1573–92), which means that it is one of the earliest examples of Shino's feldspathic glaze.

There are only two such bowls known to exist. One has

been passed down through the Maeda family of Kaga. The bowl shown here has come down through the Owari branch of the Tokugawa family.

I saw this bowl well over ten years ago, but the memory of it is still with me. It is well rounded, not at all severe like Chinese *tenmoku*. It is soft, luscious, truly representative of Japanese *tenmoku*.

There is no question that Shino ware was made at Mino during the Momoyama and early Edo periods. There is a school of thought that holds that Shino's antecedents are in the Muromachi period, and its adherents maintain that this bowl was made in Owari at that time. But the more common view is, as stated earlier, that this bowl was made in the Tenshō era, probably at Ōhira. The so-called Chrysanthemum *Tenmoku* made at Seto (Owari) adheres strictly to the style of its Chinese predecessors made at the kilns of Jian. The walls of this piece, however, have been pulled up toward the top of the body to make it more bowllike. And the trimming of the foot is different from that seen in Chrysanthemum *Tenmoku*.

It is not known when the practice of offering a bowl of tea to the Buddha image in temples began, but we do know that in the Muromachi period bowls began to be made in Japan for that purpose to supplement bowls imported from China. I have one such Japanese bowl in my collection, though it is a black-glazed piece rather than Shino ware. Also, a yellow-glazed bowl unearthed at Akatsu and thought to be from the Northern and Southern Courts period (1336–92) shows a trimmed foot similar to the one on this White *Tenmoku* piece.

6. *Gray Shino, "picture frame" shallow dish, design of grasses and flowers. W. 23.7 cm. Umezawa Memorial Gallery.*
There are perhaps ten shallow dishes in existence with "picture frame" shapes, but this piece is unique in terms of its decoration and its glaze application. The scenery deep in the mountains of Mino is depicted. The design and coloring combine to full and graceful effect.

Shallow dishes like this were produced at Ōhira, Ōgaya, and Kujiri. Each one has its own personality.

7. *Gray Shino serving dish, design of grasses. W. 16.0 cm. Hakone Museum of Art.*
Since all Momoyama period serving dishes made for use in the meal accompanying a formal tea ceremony are large, today they are often used as bowls.

This piece was originally one of a set of five, but the rest have since been sold to different owners. It is of the finest workmanship, and its gray is a perfect example of the flames of the kiln at work.

As a serving dish, it is a fine piece, but as a piece of artistic pottery, it is even more noteworthy.

8. *Picture Shino bowl, design of flowering plum branches. W. 26.9 cm. Hakone Museum of Art.*
Tenkō, the god of the kiln, clearly had a hand in this piece.

Among works of similar type, this bowl is preeminent. Its color is particularly clean, and it is considered the best example of a Shino serving bowl. Though some feel it is from Ōgaya, more likely it is a product of the Kujiri Motoyashiki kiln at its peak at the beginning of the seventeenth century.

9. *Plain Shino saké bottle; Shino Oribe saké bottle. Left: H. 17.5 cm. Right: H. 18.0 cm.*
These were excavated in the vicinity of the Ōtomi kiln. No such bottles have been handed down; all are excavated pieces. They seem to have been used as everyday ware rather than as tea ceremony pieces. Both have been repaired at the neck, but this does not detract from their appearance.

Shino saké bottles are rare. The design on the right-hand bottle is rhythmical and has a forceful beauty.

10. *Gray Shino teabowl, name:* Yama no Ha *("Mountain Ridge"). D. 13.3 cm. Nezu Art Museum.*
Yama no Ha and *Mine no Momiji* ("Summit Maple Leaves"—Plates 14, 15) are widely known and considered a pair of matchless masterpieces. This bowl's form is solid, immovable. While *Mine no Momiji* is graceful and feminine, this piece is definitely masculine. It is hard to say which is the finer of the two. Both are thought to be from the Kamashita kiln at Ōgaya.

11, 12. *Picture Shino teabowl. D. 13.5 cm.*
This bowl comes from the kilns at Ōhira. The color is a somewhat clouded, milky white. The thick walls were pulled up slowly. It has a strength not found in older bowls.

13. *Shino serving dish, repaired. H. 6.8 cm.*
This dish was unearthed at the Ōgaya Mutabora kiln. The repair seen here was done either with shards from a similar piece or with ones from a completely different pot. The color in this dish is clear and quite refined.

14, 15. *Gray Shino teabowl, name:* Mine no Momiji *("Summit Maple Leaves"). D. 13.6 cm. Gotō Art Museum.*
Mine no Momiji and *Yama no Ha* (Plate 10) are the finest examples of Gray Shino. This bowl is the Gotō Museum's prize piece. The execution is elegant and there is a bittersweet quality to the pot. The color at the hip is unique, and the incised tortoiseshell (hexagonal) and fencelike patterns give an effect resembling inlay.

16. *Picture Shino teabowl. D. 11.8 cm.*
Though technically a teabowl, this piece was not really made for drinking *matcha* (the powdered green tea used in the tea ceremony). Rather, it seems to have been intended for daily use. Apparently, quite a few Picture Shino and Shino Oribe pieces like this one were made.

From the 1530s on, the kilns at Kujiri evidently turned out many saké bottles and other miscellaneous pots. And from the early Edo period, rounded bowl-shaped pieces like this one were turned out in large numbers.

17. *Picture Shino teabowl. D. 18.0 cm.*
This bowl seems to be half in the Rikyū style and half in the Oribe style. The low foot is in Rikyū's taste. The clay is very fine, and the firing has brought out a beautiful color along with other attractive kiln effects.

18. *Shino teabowl, name:* Hagoromo *("Feather Cloak"). D. 13.4 cm.*
This heroic piece is thought to be from the Ōgaya Mutabora kiln. The potter's hands have put the expansiveness, the grandeur of the Momoyama period itself into this pot. One dreams of pouring hot water into it with a bamboo dipper made by the great Momoyama master Gamō Ujisato. One dreams, too, of some divine intervention that might allow one to sip tea from this bowl, even though it might not be quite so fine as *U no Hanagaki*.

19. *Picture Shino teabowl. D. 13.4 cm.*
This appears to be an early work in the Oribe manner, though faint reverberations of Rikyū remain. It has no name, but it is well fired, and the color is beautiful. It is rather shallow, but the workmanship is strong. It looks like a piece that might have been made by a Setoguro potter under the direction of Katō Genjūrō Kagenari.

20. *Shino tenmoku teabowl. D. 12.0 cm.*
This is perhaps a pioneer piece in the use of white Shino glaze. This bowl was unearthed from the vicinity of the Ōhira kilns. The trimming of the foot is different from that found in Chinese *tenmoku* bowls. The shape, too, is unique. Thus, it is an example of a purely Japanese *tenmoku* teabowl. The repair material is also Shino, probably from the beginning of the seventeenth century.

21. *Picture Shino teabowl, name:* Matsushima *("Pine Islands"). D. 13.0 cm.*
This masterpiece has a fine, assymetrical shape. There seems no mistaking that it was made at the Ōgaya Kamashita kiln. In contrast to the heroic taste of the Momoyama period, this bowl is refined and temperate. The walls lean slightly inward, the hip swells out quietly. The potter's artistry is locked deep inside the bowl. The name of the piece comes from the picture on the side, which depicts one of the famous pine-covered islands of Matsushima.

22. *Picture Shino, small serving dishes* (mukōzuke), *four-sided with pinched-in corners. H. 6.8 cm.*
These thin-walled and graceful dishes are highly prized as rare and elegant examples from the Ōgaya kilns. It is hard to tell whether the pictures are of pine trees and a mountain peak or grasses growing at the base of the mountain, but such abbreviated designs are common in early products from the Ōgaya potters. As small serving dishes for the tea ceremony meal, these are unsurpassed.

23. *Picture Shino bowl, design of flying birds. D. 16.8 cm.*
The rim is slightly inverted, and the bowl is supported by three feet. The piece was fired at Ōhira sometime in the early seventeenth century. On the inside bottom are three marks, probably the result of stacking the piece in the kiln. The pot is rather large for a serving dish and functions better as a bowl. It is solidly made.

24. *Picture Shino serving dish, design of iris. D. 19.0 cm.*
An older associate of mine believes this is "only" a Picture Oribe work, but I am inclined to think it is a product of the Kujiri kilns from sometime after 1615. The overglaze is thinly applied so that the picture shows clearly. Iris designs are rather frequent in Shino pottery. Today, as in times past, irises in graceful bloom are a common sight around Mino during the rains of late spring.

25. *Deep serving bowl, protruding decorations. H. 8.1 cm.*
This pot is decorated with designs of a cypress fence and grasses and flowers. The color is splendid. Undoubtedly it was used as a serving dish, but it seems better suited as a holder for embers that tea ceremony guests might use to light pipes while waiting to enter the tea room. The buttons of clay stuck onto the sides of the pot are very effective.

26. *Picture Shino, cylindrical serving dish, designs of willow and bush clover. H. 9.7 cm.*
This product of Ōgaya could easily pass nowadays for a cylindrical teabowl. With a willow design on one side and a bush clover design on the other, it can conveniently be used either in the spring or the autumn. The color is exquisite, and Tōkurō Katō once praised it as the finest coloring he had ever seen. But surely this hue is the work of the flames. No human could have made it on purpose.

27. *Picture Shino serving dish, design of pampas grass. D. 16.8 cm.*
The superb design takes careful consideration of empty space. The dark blots surrounding the picture of pampas grass look for all the world like a line of bald priests linked together by tendrils of grass.
The piece is well fired; the color is clear. The overall effect is calm and quiet.

28. *Gray Shino serving dish, design of grasses and flowers. D. 17.2 cm.*
Probably from the Kujiri Inkyo Omote kiln, this fine piece was fired carefully. The design of grasses and flowers is ingratiating. The dish stands on three feet. It is owned by a lover of Shino ware who lives in Niigata Prefecture.

29. *Picture Shino serving dish, design of autumn grasses. W. 15.8 cm. H. 4.7 cm.*
This was fired either at the Kujiri Motoyashiki kiln or at one of the Ōgaya sites. It is very thin, and the beauty of the lines is exquisite. The potter has used iron-rich *oni-ita* clay for the design. The fine distribution of light and dark is not at all mannered. This dish would be at its best as part of the service at a tea ceremony meal.

30. *Picture Shino serving dish. W. 15.8 cm. H. 5.5 cm.*
The firing has produced a soft effect sure to charm any connoisseur of Shino tea ceramics. The designs on the rim could represent trees, grasses, or perhaps wisteria flowers. The depth and effect of this dish are intoxicating. Surely it must be the product of an early seventeenth century kiln.

31. *Picture Shino serving dish. W. 15.4 cm. H. 6.3 cm.*
It seems safe to say that this is a dish from the Keichō era (1596–1615), when Furuta Oribe was alive and at his most active. It is a masterpiece on all counts: the design of the picture, the glazing, and the effects of the firing. The shape, called *mokko* (a basket attached to a shoulder carrying pole by a kind of string cradle), is relatively common among serving dishes.

32. *Gray Shino serving dish, design of grasses. W. 16.0 cm. H. 6.0 cm.*
Because it is well fired, the colors emerge clearly in the dish. It imparts a pleasant feeling. Although designed as a serving dish, it can also be used as a bowl because it is so large.

33. *Gray Shino bowl, design of grasses. W. 15.9 cm. H. 3.6 cm.*
The piece was first covered thickly with an iron glaze, then the design was incised with a pointed bamboo tool. This method brings out the white of the feldspathic glaze. The lines are beautiful, the overall effect strong. Such pieces as this clearly illustrate the bold techniques favored by the Momoyama potters.

34. *Picture Shino bowl, protruding decorations. D. 23.8 cm. H. 8.0 cm.*
Thought to be from the Motoyashiki kiln, this bowl was probably made in the first or second decade of the seventeenth century. Although it is not too clear, the picture seems to be a scene of a mountain village in Mino. The boldness of the plate is very much in the style of the Momoyama artists. Not a lot of time was spent on making this pot, but its lack of attention to detail is one of its charms.

35. *Picture Shino serving dish, design of heron. W. 16.4 cm.*
As they did in the past, herons still come today to the area around Kujiri. This piece, which could just as well be called a plate, has the *mokko* shape (see Caption 31) much favored in the Momoyama period. This is one of a set of five, and only one of these five has a maker's mark, which is not legible.

36. *Picture Shino small four-sided bowl. D. 15.4 cm. H. 6.0 cm.*
The design depicts drying fish nets and a flying bird that appears to be a thrush. It is a nature poem on the mountains of Mino. The lip has been bent inward so that it overhangs—a technique peculiar to this period. Many serving dishes have a similar shape.

37. *Shino Oribe saké server. H. 18.0 cm.*
The forceful shape is first-rate. In its fullness one can see the face of the Momoyama potter. The lid seems to have been fired separately, for the effects left on it from the firing are somewhat different, though outstanding in their own way. On the lid is a tortoiseshell pattern and a three-legged knob. The "hinge" buttons attached to the handle are a wonderful touch.

38. *Plain Shino fish-shaped water dropper; Green Oribe fish-shaped water dropper. L. 10.6 cm.*
These were both made at Kujiri. The green glaze is called Oribe; the cloudy white one is called Shino. Together they are referred to as Shino Oribe.

39. *Gray Shino catfish-shaped incense box, designed by Seison Maeda. L. 6.2 cm.*
The late modern master painter Seison Maeda designed this for fun. It was fired in Toyozō Arakawa's kiln. The painter was born in Nakatsugawa, in Mino, and was inordinately fond of the tea ceramics made in his home district.

40. *Picture Shino ember holder, design of shellfish. H. 8.5 cm.*
This piece features a bold design on a drum-shaped body supported by three feet. It is a rare work and comes from the Motoyashiki kiln in its finest days.

41. *Picture Shino incense box. D. 6.0 cm.*
The design appears to be of grasses. This is one of the finest examples of Picture Shino and as such has always been treated by those interested in the tea ceremony as a treasure. It was made early on by a master potter at Ōgaya. One has to admire the beautiful way in which its thin walls were formed on the wheel.

42. *Plain Shino incense box, by Toyozō Arakawa. H. 3.2 cm.*
This is a work by Toyozō Arakawa, who has been designated a "Living National Treasure." Representative of modern Shino ware, the piece is tranquil, yet tightly structured. The application of the feldspathic glaze is too much for words to describe.

43. *Picture Shino incense box. H. 4.5 cm.*
If the incense box in Plate 41 is of the top rank, this is just one step down. Being from the Ōhira kilns, it is not overly smart looking, but it has a strength to it. The manner in which it was made resembles that of the saké pot in Plate 47, and both may well have been created by the same person. Though it is tiny, it has the power and intensity of a much larger piece.

44. *Picture Shino "picture frame" bowl, design of grasses and flowers. W. 13.0 cm. H. 5.0 cm.*
"Picture frame" bowls were apparently fired at the Kujiri Inkyo Omote, Ōgaya Mutabora, and Ōhira kilns. They were made with molds. The straightforward, elegant picture complements the outlines of the pot.

45. *Picture Shino deep bowl, design of grasses and flowers. H. 18.0 cm.*
The *mokko* shape (see Caption 31) is decorated with grasses,

flowers, and spirals, and supported by three feet. Although the piece is thought to have been made in the Edo period, something of the Momoyama taste can be found in its large size. Its air is restrained.

46. *Picture Shino "picture frame" bowl, design of Chinese buildings and human figures. W. 15.2 cm. H. 3.9 cm.*
The scene depicted here is Chinese in feeling, not at all like the area around Mino. It might just as easily be called Picture Oribe, and was probably made sometime in the third or fourth decade of the seventeenth century. One has to admire the free and stirring quality of the picture, but all in all the pot is rather outside the mainstream of Shino.

SHINO WARE FOR USE IN THE TEA CEREMONY MEAL

47. *Shino Oribe saké pot. H. 16.8 cm.*
This saké pot was made at Kujiri sometime after 1615. It also makes a fine water container for the tea ceremony. Though some repairs have been made on the spout, the handle is in perfect condition. The horizontal lines drawn around the bulge at the sides are childish yet charming. At first glance their three-tiered structure looks clumsy, but it is in fact pleasing. The pot is perfect for use during the tea ceremony meal.

48. *Picture Shino shallow bowl. W. 24.8 cm. H. 5.0 cm.*
The design is of trees growing around a brushwood gate. One occasionally sees scenes like this. The firing has brought out the markings on the rim very nicely. Though the plate was designed for serving fish, it would also suit cooked vegetables quite well.

49. *Gray Shino bowl, bracken fern design. D. 26.2 cm. H. 5.7 cm.*
This bowl, with its design of bracken fern made by incising the slip coating, is most unusual. Fire marks serve to give it a forlorn beauty. Its potential uses in the tea ceremony meal are numerous: cooked fish, boiled vegetables, fruit served after the meal....

50. *Plain Shino saké cups. D. 7.1 cm. H. 4.0 cm.*
There is something delicate and different about the way the feet have been trimmed on these cups from the kilns at Ōgaya. Although all five were made together as a set, one of them differs from the others in shape. The charm of these cups lies in their beautiful loneliness and in their elegance, which partakes of the spirit of tea in a way that is hard to put into words. They might be used to serve pickled squid entrails at the tea ceremony meal. One alone would make a nice saké cup for less formal drinking.

51. *Plain Shino saké cups. Left: D. 6.5 cm. Middle: D. 6.8 cm. Right: D. 5.9 cm.*
These three cups were all excavated. Since there are no other extant cups like them, probably very few were made. Or perhaps they were just common household utensils, not highly prized enough to be handed down from one generation to the next. Their various surfaces have a special charm.

52. *Picture Shino deep, square serving dish (mukōzuke). H. 7.0 cm.*
This is a superb piece made by some highly skilled potter at Ōgaya in the late 1590s. It is splendid for the tea ceremony meal.

53. *Picture Shino "picture frame" bowl, design of wild grapes. W. 24.0 cm. H. 5.1 cm.*
There are any number of pieces with the same shape, but the design of wild grapes on this bowl is special. It is subtly repeated by the abstract configurations at each of the four corners. The glaze is thin, the workmanship fine. The bowl would be perfect for serving cooked vegetables or cakes.

SHINO TEABOWLS BY CONTEMPORARY POTTERS

54. *Picture Shino teabowl, by Shuntō Katō. D. 12.9 cm.*
Shuntō Katō is one of the representative potters from Seto. He does not specialize exclusively in Shino, but true to his reputation, he has created a powerful bowl here. One can see in it a proud desire to uphold the Seto tradition and not yield to Mino. The artist was born in 1916.

55. *Red Shino teabowl, by Seizō Katō. D. 13.1 cm.*
This potter is the thirteenth generation of the line of Katō Kageaki, one of the founders of pottery at Mino. He operates the Gengetsu kiln at Kujiri and is striving to bring about a Momoyama revival. The bowl shown here is a congenial and modern piece. Seizō Katō was born in 1930.

56. *Picture Shino teabowl, by Osamu Suzuki. D. 13.4 cm.*
Osamu Suzuki is one of the most highly regarded of the potters at Mino. He is conscientious about his work and has the natural temperament to be a great artist. This shows in his pots. He was born in 1934.

57. *Plain Shino teabowl, by Seisei Suzuki. D. 13.0 cm.*
Seisei Suzuki could be considered the best of the potters from Seto. He does not limit himself only to Shino ware; rather, his interests and great energy cover a wide range of techniques. His style is magnanimous. He was born in 1914.

58. *Picture Shino teabowl, by Hidetake Andō. D. 13.1 cm.*
The iron underglaze decoration is bold, the glaze on the bowl is thick. The foot is artless but powerful. Andō is the best of the young Shino potters. His individual style is praiseworthy. He was born in 1938.

59. *Picture Shino teabowl, by Kōzō Katō. D. 12.6 cm.*
Although he established his kiln only in the late 1960s, Kōzō Katō's heavy, thick style has already won a following among connoisseurs. His work is not inferior to that of older, more established potters. He was born in 1935.

60. *Plain Shino teabowl, by Yasuo Tamaoki. D. 13.2 cm.*
Tamaoki is already at the center of Shino activity. He approaches the Shino aesthetic with passion and pleasure. He was born in 1941.

61. *Gray Shino teabowl, design of flying cranes, by Toyozō Arakawa. D. 12.8 cm.*
The flying cranes on this bowl were made by using a wax resist technique. But the bowl shows far more than Arakawa's skill at drawing.

Arakawa was born in 1894 and has been designated a "Living National Treasure." His discovery of an old Shino kiln at Ōgaya in 1930 was a tremendous contribution to ceramics. His works represent the best of modern Shino.

62. *Picture Shino teabowl, by Tōkurō Katō. D. 14.2 cm.*
This strong bowl has been well fired. Its white is eye-catching. Tōkurō Katō is generally conceded to be the best living Shino potter in terms of actual ability. He is a superb rival of Toyozō Arakawa, the two being like dragon and tiger. Born in 1898, Katō is a "man of fire" who exemplifies the true spirit of the Artist.

63. *Gray Shino teabowl, by Rosanjin Kitaōji. D. 10.8 cm.*
The shape of this bowl is similar to the work of Hon'ami Kōetsu, but in every other way—the forceful throwing of the pot, the bold and seamless glazing—it is Rosanjin's own. This virtuoso artist died in 1959, but the popularity and critical evaluation of his works have risen each year.

64. *Picture Shino teabowl, design of Chinese bellflowers, by Naoki Nakayama. D. 12.7 cm.*
Nakayama is one of Toyozō Arakawa's most talented pupils and a potter from whom great things are expected in the future. As this bowl shows, he favors simple drawings on his works. He was born in 1933.

65. *Gray Shino teabowl, by Takuo Katō. D. 12.8 cm.*
This leader in Mino pottery circles has an intensely devoted involvement in ceramics. His work shows the best of modernist Shino. He was born in 1917.

66. *Picture Shino teabowl, by Kōtarō Hayashi. D. 13.1 cm.*
Born in 1940, Hayashi is a bright new talent. His work projects a vigorous self-confidence. His younger brother Shōtarō also shows great promise.

67. *Plain Shino teabowl, by Kenji Kishimoto. D. 12.5 cm.*
Though born in 1938, he already shows the characteristics of a great master. Kishimoto's works, pleasing to the eye, give concrete expression to the beauty of Shino.

68. *Gray Shino teabowl, by Toshisada Wakao. D. 13.7 cm.*
Devoted to Shino, where teabowls are supreme, Wakao stands at the forefront of the new potters. He was born in 1933.

69. *Plain Shino teabowl, by Shuntei Katō. D. 12.0 cm.*
This artist comes from a long line of skilled potters at Akatsu, in the city of Seto. He was born in 1927. The bowl shown here expresses, in a restrained way, the forlorn beauty of last traces of unmelted snow.

Mino Kiln Sites

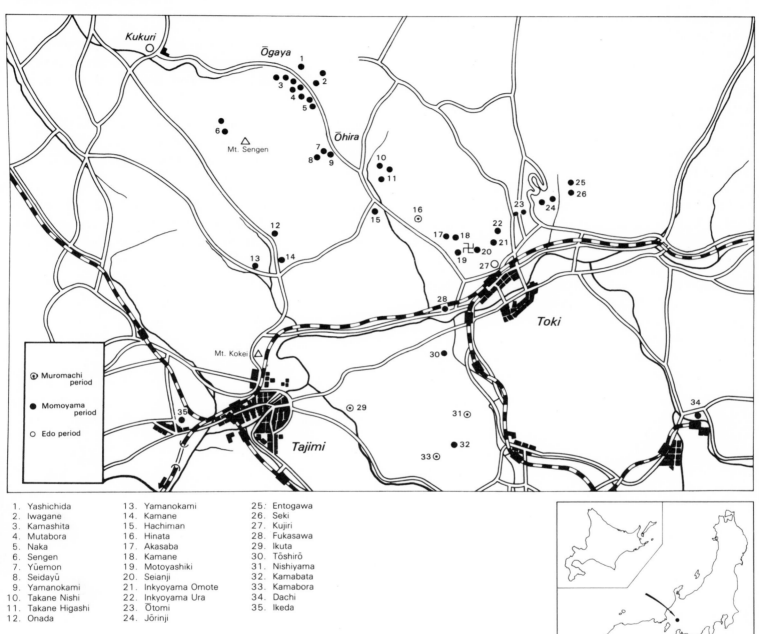

1. Yashichida	13. Yamanokami	25. Entogawa
2. Iwagane	14. Kamane	26. Seki
3. Kamashita	15. Hachiman	27. Kujiri
4. Mutabora	16. Hinata	28. Fukasawa
5. Naka	17. Akasaba	29. Ikuta
6. Sengen	18. Kamane	30. Tōshirō
7. Yūemon	19. Motoyashiki	31. Nishiyama
8. Seidayū	20. Seianji	32. Kamabata
9. Yamanokami	21. Inkyoyama Omote	33. Kamabora
10. Takane Nishi	22. Inkyoyama Ura	34. Dachi
11. Takane Higashi	23. Ōtomi	35. Ikeda
12. Onada	24. Jōrinji	